Literary • paris
Landscapes

Pavilion
An imprint of HarperCollins*Publishers* Ltd
1 London Bridge Street
London SE1 9GF

www.harpercollins.co.uk

HarperCollins*Publishers*
Macken House,
39/40 Mayor Street Upper,
Dubiln 1
D01 C9W8

10 9 8 7 6 5 4 3 2

First published in Great Britain by Pavilion, an imprint of
HarperCollins*Publishers* Ltd 2023

Copyright HarperCollins*Publishers* © 2023

Dominic Bliss asserts the moral right to be identified as
the author of this work. A catalogue record for this book is
available from the British Library.

ISBN 978-0-00-858899-1

This book is produced from independently certified FSC™
paper to ensure responsible forest management.

For more information visit:
www.harpercollins.co.uk/green

Commissioning Editor: Frank Hopkinson
Designer: Lily Wilson
Layout: Cara Rogers
Photo Research: Sébastien Sourdille
Additional text: Pavilion Editorial

Printed and bound in Dubai by Oriental Press

Dominic Bliss

Foreword by Sandrine Voillet

Literary • paris Landscapes

From Hugo to Hemingway, the cafés and bookshops of the City of Light

PAVILION

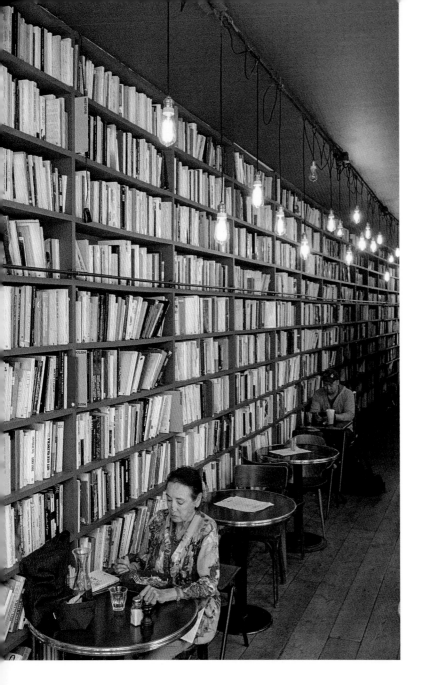

Foreword

My passion for books started early. At first they were a way to make imaginary travels as a child, then they became my refuge as a teenager before I finally became a compulsive reader and buyer as an adult. If some women can't resist buying a pair of shoes, I can't resist buying a book when I step into a bookshop. So here I am, part bibliomaniac, part *tsundoku* – the Japanese expression to designate people who own a lot of unread literature: books fill up every nook and cranny of my small Parisian flat. I remember reading about Umberto Ecco and his 50,000 books and how the ideal library might not be about the books we read but about the books we want to read. If that sounds familiar to you, then you'll certainly feel at home in Paris.

Beyond the most iconic bookshops such as Delamain or Galignani, there are many other independent bookshops, both in Paris and France more generally. The vocation of these passionate booksellers is to open new horizons to readers and to unveil amazing stories by unsung authors. These bookshops feel a little like a social club where booksellers will discuss willingly their last *coup de coeur* or write short compelling notes on the books they want to promote. There is a quote from Virginia Woolf's diary you will find later on these pages that perfectly expresses the French bookseller.

The role of bookshops has appeared so essential that during pandemic lockdowns, books were considered an essential need, so bookshops were allowed to stay open in France alongside food stores and pharmacies. Food for thought.

Another phenomenon that has spread across Paris and the rest of France recently has been the emergence of the *boîtes aux livres*, or book boxes. Available at many public spaces – in Jugon les Lacs, Brittany, they use an old public phone box – you will find books at everyone's disposal, ready to be borrowed, read and returned without the intervention of librarians. People are invited to offer the books

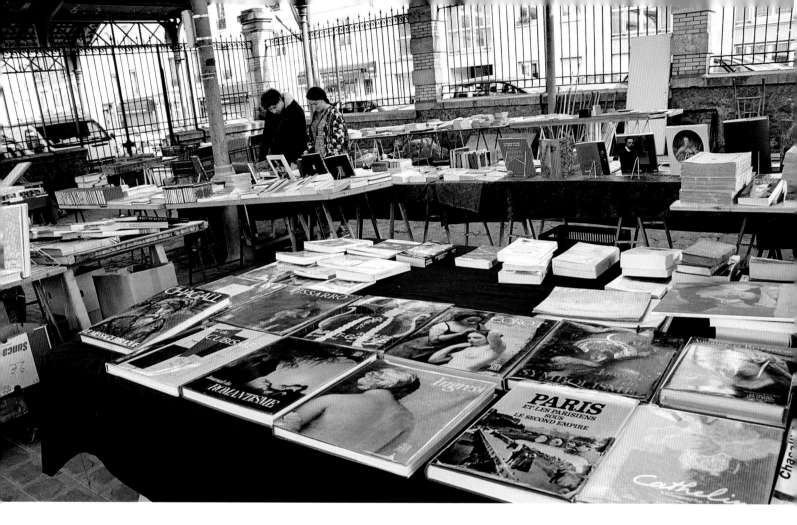

they read or no longer want to keep. This virtuous circle of sharing the love of literature with others and recycling books has been a real success.

My friends from abroad are always impressed to see people reading paper books in the Métro while they're commuting. As if literature was somehow part of the French DNA; Parisians can't resist stopping at a box of books put out in front of a bookshop.

As a student, I remember saving money to buy art books from Éditions Mazenod worth the equivalent of 150 euros at the time. A small fortune for me; however, I was so proud when I managed to buy two second-hand

ABOVE Paris is famous for its art and art bookshops, and bibliophiles struggle to resist the temptation.

OPPOSITE There are no books for sale at the Merci used book café; customers have bookshelves to choose from while drinking a grand crème.

Mazenods at the Gibert Jeune bookshop, a real student institution in the Latin Quarter which sadly closed in 2021. Nowadays I feel puzzled when I see art books selling for 30 euros in bargain boxes outside bookshops, I can't help thinking, 'well, times have changed'. But I do find comfort in the idea that art books are more accessible to a larger audience.

During my many strolls across the city, I like making a detour to the Librairie du Passage Jouffroy next to the Grévin Wax Museum. It looks like a quaint, wooden shop but inside there's a true Ali Baba cave for collectors looking for rare books, or students searching for a specific reference.

Paris itself is a book with a story to be told at every corner. I often lead visitors down the Paris arcades (*passages couverts*), following in the footsteps of *flâneur* poet Charles Baudelaire, stopping by the Jousseaume bookshop in Galerie Vivienne opposite the French National Library. People once went there to purchase books but also to read the press in a reading room for a small fee, as only a small set of wealthy people subscribed to newspapers at the time.

We also wander off the beaten tracks, for example visiting little gems such as L'Hôtel where Oscar Wilde lived during his final days. Then in Montmartre we have Le Bateau Lavoir, the home of Cubism. The famous artists' workshop was also frequented by poets Guillaume Apollinaire and Max Jacob. The square where the Bateau Lavoir used to stand is named Place Émile Goudeau after the founder of a famous literary club called Les Hydropathes.

Many locations in Paris are linked to the names of authors. The Marquise de Sévigné, a famous seventeenth-century woman of letters, was born in Place des Vosges in Le Marais, just a few private mansions away from the house where

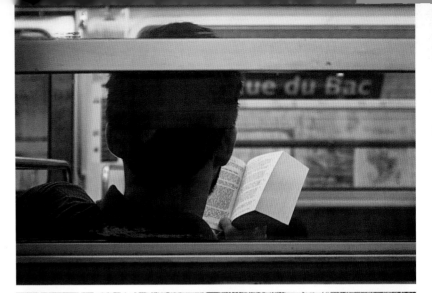

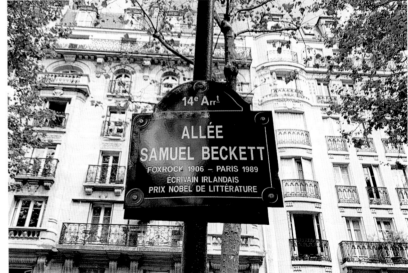

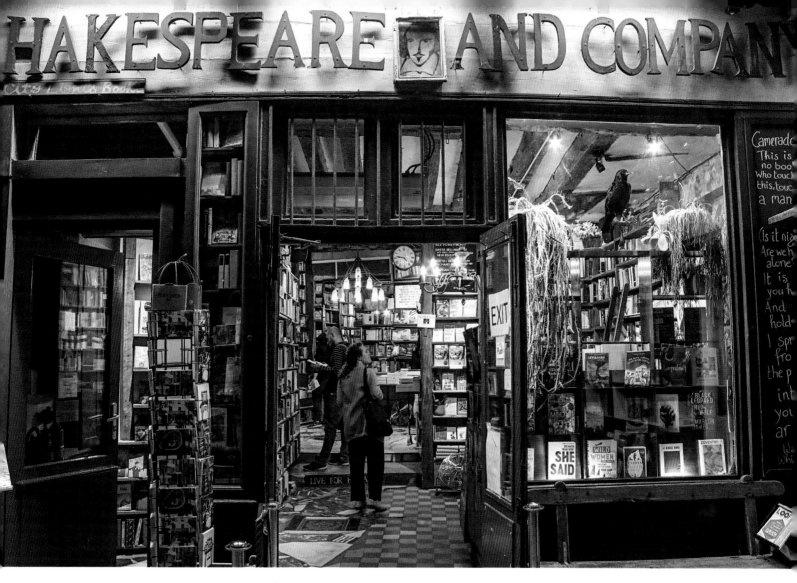

ABOVE LEFT Parisians still read paper books on the Métro.

LEFT A street named for Samuel Beckett, close to where he lived during World War II, and from where he helped the French Resistance.

ABOVE Shakespeare and Co, like many Paris bookshops, opens late into the evening.

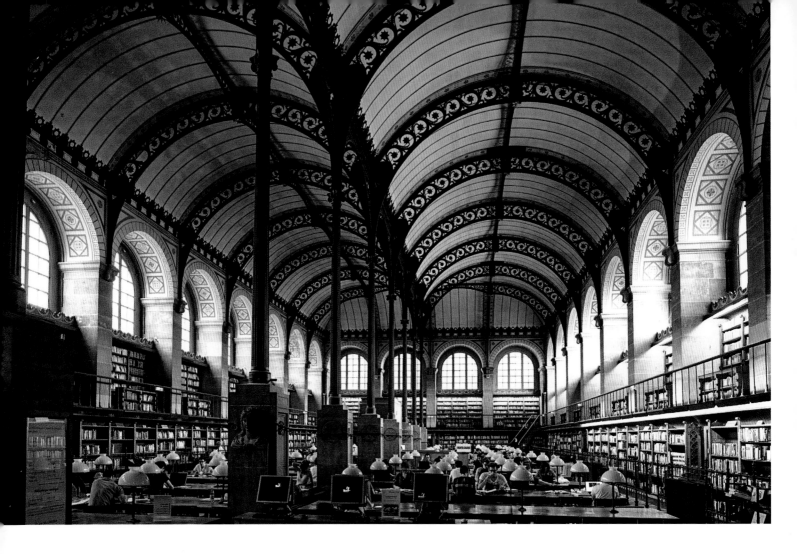

ABOVE The Bibliothèque Sainte Geneviève at the Sorbonne university. In French, *librairie* translates as bookshop.

OPPOSITE TOP Ma Bourgogne restaurant in the Place des Vosges was a favourite of Inspector Maigret.

OPPOSITE Sandrine Voillet in the Palais-Royal.

Victor Hugo lived between 1832 and 1848. Both have roads named in their memory along with Molière, Voltaire and there is even an Allée Samuel Beckett, after the great Irish playwright who worked for the Resistance in World War II and wrote his classic *Waiting for Godot* in French.

We could even say Paris is a subject in itself, a character in its own right. The name of the city evokes many stories from *Notre Dame de Paris* by Victor Hugo to *Au Bonheur des Dames* by Émile Zola. But Paris was also

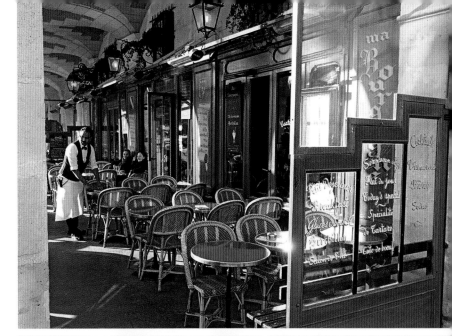

a refuge for authors who fled prejudice, like Oscar Wilde, Richard Wright and James Baldwin, or acted as a moveable feast for the American Lost Generation and attracted many writers like a magnet from all around the world.

This book will introduce you to the places which enshrined the reputation of Paris as a literary capital: From the oldest café in Paris, Le Procope, where the philosopher Voltaire had his desk, to the Shakespeare and Co. bookstore, where so many Americans come on pilgrimage, following in the footsteps of the Beat Generation. From the prestigious Gallimard publishing house (owners of the Delamain bookshop) with its 38 Prix Goncourt winners and 38 Nobel Prizes for Literature, to the Bouquinistes, the green book stalls punctuating the banks of the river Seine. And there is the obligatory mention of the Café de Flore where tourists come to immerse themselves in the spirit of existentialism... or simply pose.

I'm sure you'll be drawn to Paris after reading this book. You might even end up with the same compulsive addiction for collecting them. As philosopher Walter Benjamin said: 'Paris is the great reading room of a library through which the Seine flows.'

Personally, I decline the temptation of getting rid of books. However, I have been improving. Over the years I managed to stop myself from picking up books left on the ground after the Montreuil flea market. It's a sacrilege to let rot a product of the mind!

Sandrine Voillet

We left our luggage and walked out to have dinner in a small restaurant on Boulevard Raspail. Walking out we got into a bookshop where V. bought *J'adore* by Jean Desbondes and I bought *L'Immortaliste*. There was an old man sitting in the bookshop and he and the proprietor (a woman) fired off a rhapsody about Proust. We observed how this (sort of thing) could never happen in England.

Virginia Woolf with Vita Sackville-West
on a visit to Paris, 24 September 1928

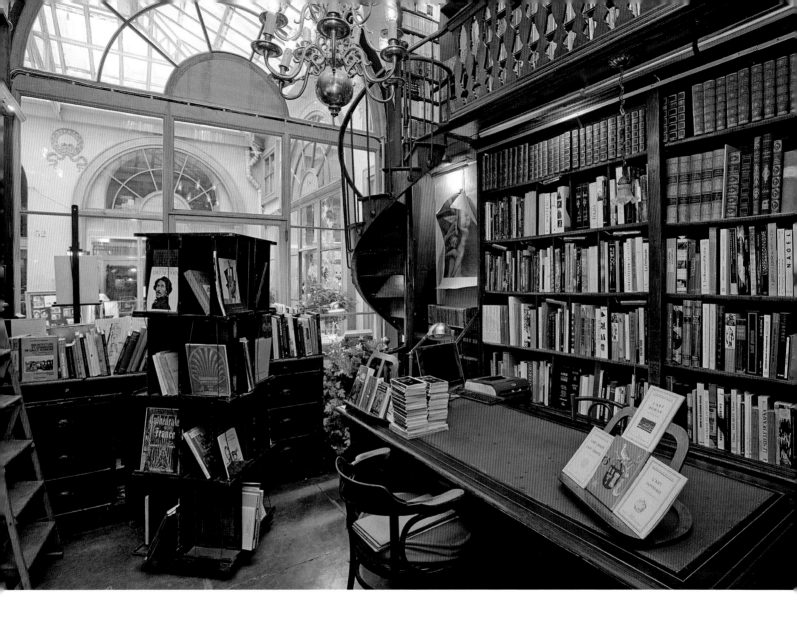

ABOVE François Jousseaume's
bookshop in the Galerie Vivienne.

BOOKSHOPS

Abbey Bookshop

29 Rue de la Parcheminerie

Rue de la Parcheminerie, a skinny little passageway in the Latin Quarter, is steeped in literary history. In the Middle Ages, this was the centre of Paris's parchment-making industry – hence the name. Before that it was called Rue des Escrivains, after the medieval scribes who worked there.

Nowadays it is home to one of Paris's most famous English-language bookstores, the Abbey Bookshop. First established in 1989 by Canadian bibliophile Brian Spence, it's one of those establishments so gloriously overflowing and stacked high with books that, inside, it's like a labyrinth, while outside, the stock spills out onto the pavement, luring you in. Spence himself claims to stock over 40,000 titles in English, ranging from scholarly to popular literature – most of them second-hand, and a fair proportion of them Canadian. He'll often regale his customers over a complimentary cup of coffee.

The building itself, with its lovely façade, decorative sculptures and carved doors, used to be the Hôtel Dubuisson, one of the Latin Quarter's favourite hotels back in the eighteenth century.

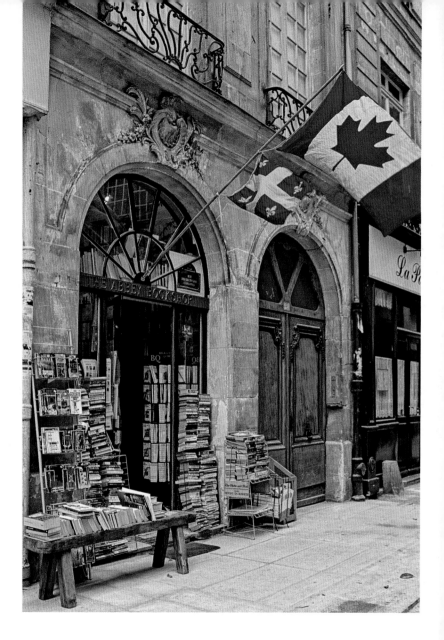

ABOVE The Abbey Bookshop displays its Quebecois heritage.

RIGHT Finding a title on the shelves of the Abbey is often a journey of discovery.

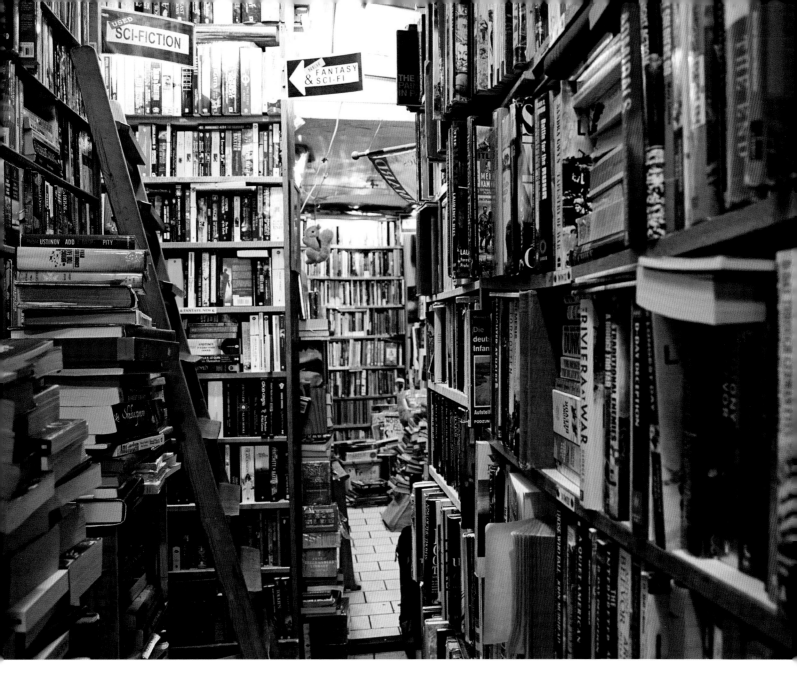

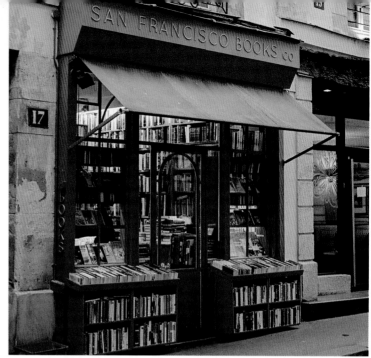

Librairie des Alpes

6 Rue de Seine

San Francisco Books Co

17 Rue Monsieur le Prince

Such is the sophistication of the French book market that it can still sustain quirky and specialist bookshops. And in this rarefied retail atmosphere the Librairie des Alpes at 6 Rue de Seine is still in business, catering to mountaineers, hikers and more generally to lovers of mountains, not simply the Alps. It was opened in 1933 selling both ancient and modern books with mountain and mountaineering subjects. Today it has over 10,000 titles in stock. Over the years it has branched out into hosting photographic exhibitions from major climbs as well as selling photo books and vintage prints. It is also a focal point of the mountain climbing community in Paris, the unofficial base camp.

If you feel like making a pilgrimage to Richard Wright's former apartment in Rue Monsieur le Prince (see page 122) that will bring you almost to the door of the San Francisco Books Co. The California city has a strong connection with Paris – Lawrence Ferlinghetti, founder of San Francisco's famous City Lights bookshop came to study at the Sorbonne after the war, and when he got back to California he opened a book store very much like the ones he'd visited on the Left Bank. The San Francisco Book Co. in Paris was founded in 1997 and specialises in second-hand books. There's usually a buyer in the bookstore every day if you have something to sell, though preferably a shelf-full.

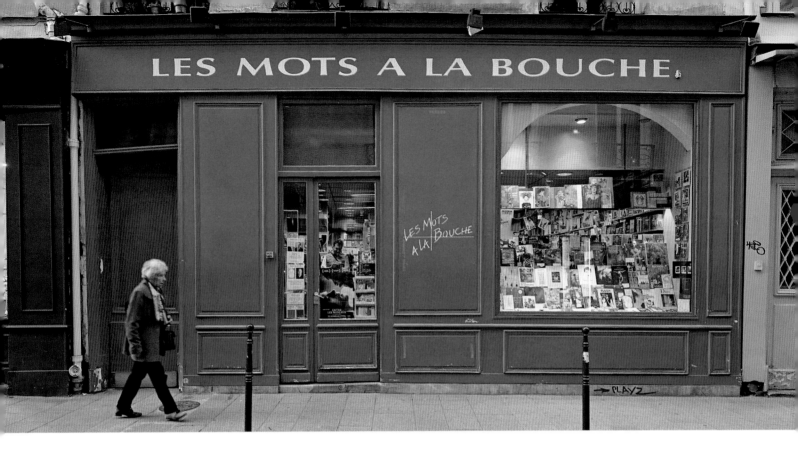

Les Mots a la Bouche

37 Rue Saint-Ambroise

First opened in 1980 by Jean-Pierre Meyer-Genton in Rue Simart, pioneering LGBT bookshop Les Mots a la Bouche only found success after a move to Rue Sainte-Croix-de-la-Bretonnerie in 1983. At the time, the Marais was not really a gay district, with only three other businesses catering to the LGBT market. Since then the district has gentrified, forcing up rents (a typical malaise for bookshops across Paris) and forcing Les Mots to move. Such is the importance of bookshops that in 2019 the City of Paris stepped in to help find new commercial premises for the store and its 12,000 titles. It has settled in at 37 Rue Saint-Ambroise not far from Père Lachaise cemetery.

Artazart

83 Quai de Valmy

'Our heart is made of paper,' claim the proud aesthetes who own this colourful design bookstore on Canal Saint-Martin, in the 10th arrondissement. The shop is difficult to overlook with its vibrant postbox-red (or should that be phrygian-cap-red?) façade. Carl Huguenin and Jerome Fournel, who specialise in photography, design, fashion, illustration, graphic novels and children's books, first set up business as an online bookshop back in 1999. Since then, Artazart has grown steadily, thanks in no small part to a collaboration with Serge Bensimon, founder of the Monaco fashion brand Bensimon.

Much of the shop's success stems from its ability to draw in punters through exhibitions, launches and signings. These have included photographers such as Martin Parr, Steve McCurry, Stephen Shore and Antoine d'Agata, the artists Pierre et Gilles, and the designer Matali Crasset.

'Paper will never die,' insist Carl and Jerome, in defiance of today's domination of the market by digital publishers. 'Long live the book!'

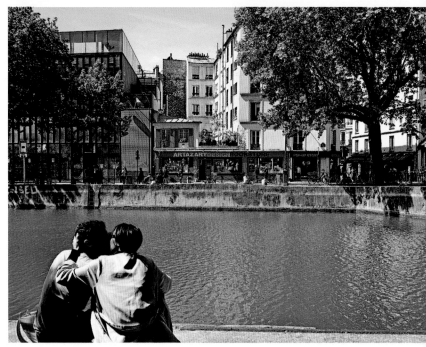

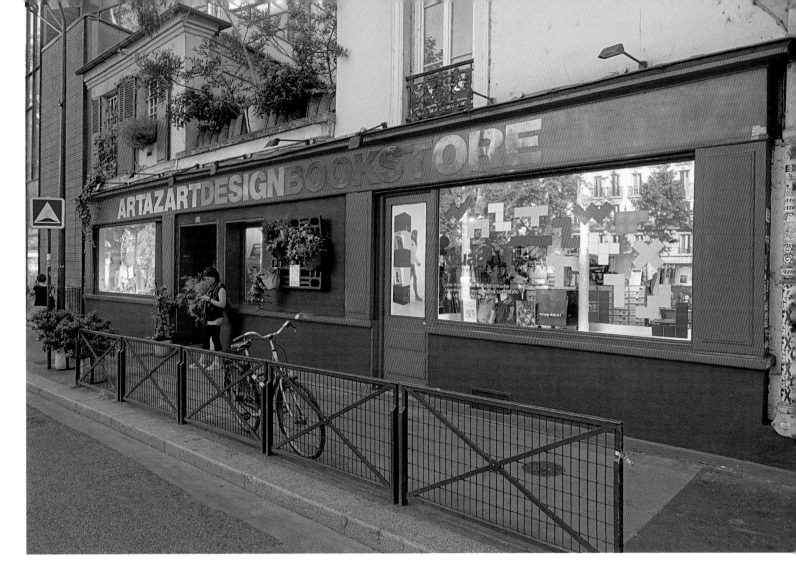

ABOVE LEFT Books are displayed to give maximum graphic impact.

LEFT The bookshop is sited right next to the Canal Saint-Martin

ABOVE Like an increasing number of bookshops in Paris, Artazart bills itself as a librairie/galerie, with important exhibition space.

Librairie Auguste Blaizot

164 Faubourg Saint-Honoré

Distinctly upmarket and firmly on the Right Bank, the Librairie Auguste Blaizot at 164 Faubourg Saint-Honoré is arguably the most famous antiquarian bookshop in France. It takes its name from Auguste-Charles Blaizot, born in 1874 at Blainville-sur-Mer on the Normandy coast who, as a fifteen-year-old, moved to Paris to work with his uncle, Émile Lecampion, a bookseller in the Passage du Saumon. In 1902, he took over the bookshop, now located at 22 Rue Pelletier, and in 1905 changed its name to Librairie Auguste Blaizot. After fifteen years in the Boulevard Haussmann, Blaizot moved to the current address in 1928.

Auguste Blaizot and the following generations have developed an important publishing role. Alongside the sale of rare and ancient books, they have published classic novels and collections of poetry including unpublished works of Victor Hugo. Today, the Blaizot family continues to welcome bibliophiles into their exclusive and suitably elegant store.

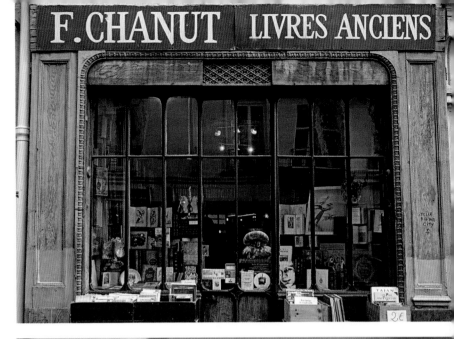

Librairie François Chanut

41 Rue Mazarine

Across the river from Blaizot, more than a dozen antiquarian bookshops can be found in the Latin Quarter, each with its intoxicating smell of old leather and aged bindings, and Librairie François Chanut at 41 Rue Mazarine is typical of its kind. Selling books from the nineteenth century onwards, it has survived the lack of footfall brought about by Covid restrictions, by selling online, stocking a typically wide range of subjects from romantic books, history, gastronomy, arts and crafts, folklore, poetry, art and travel, to modern illustrated books. Today it is run by Valerie Chanut.

Librairie Delamain

155 Rue Saint-Honoré

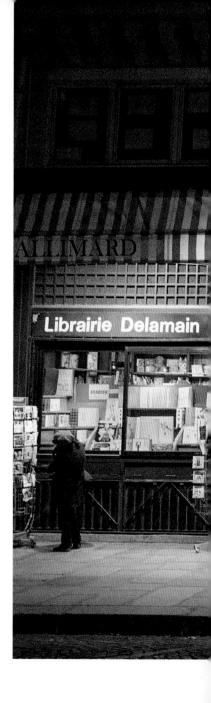

The oldest bookshop in Paris, Librairie Delamain was first opened for business in the early 1700s – beneath the arcades of the Comédie-Française theatre – by publisher André-Charles Cailleau. In 1906, after a fire at the theatre, it relocated to its new address across the road, at 155 Rue Saint-Honoré. Nowadays it is part of the Gallimard publishing empire.

Over the years, Delamain has been a favourite haunt of many a famous French writer, including Alexandre Dumas, Guy de Maupassant, Jean Cocteau, Colette, and Michel Foucault. It was in this bookstore that film director François Truffaut first discovered the Henri Pierre Roche novel, *Jules et Jim*, which he later turned into a successful movie in 1962. Historians, philosophers and politicians, too, have found comfort in the shop's vast collection of books, both modern and antiquarian. Even François Mitterrand, who was president of France from 1981 to 1995, stocked his personal library with many books purchased here.

But recent times have been tough for Delamain. In 2014, threatened by a sharp rise in rental costs imposed by the Qatari building owners, the shop almost closed. Last-minute interventions by the then minister of culture, Fleur Pellerin, and author Angelo Rinaldi resulted in a stay of execution. 'It's only when Granny is sick that you realise how much you love her,' said the latter.

Delamain, the revered old grandmother of Paris's bookshops, has always been loved more than most.

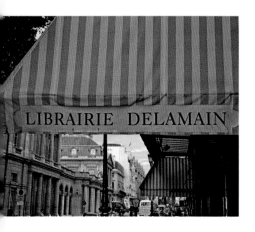

ABOVE The Parisian institution was rescued by the Gallimard publishing empire.

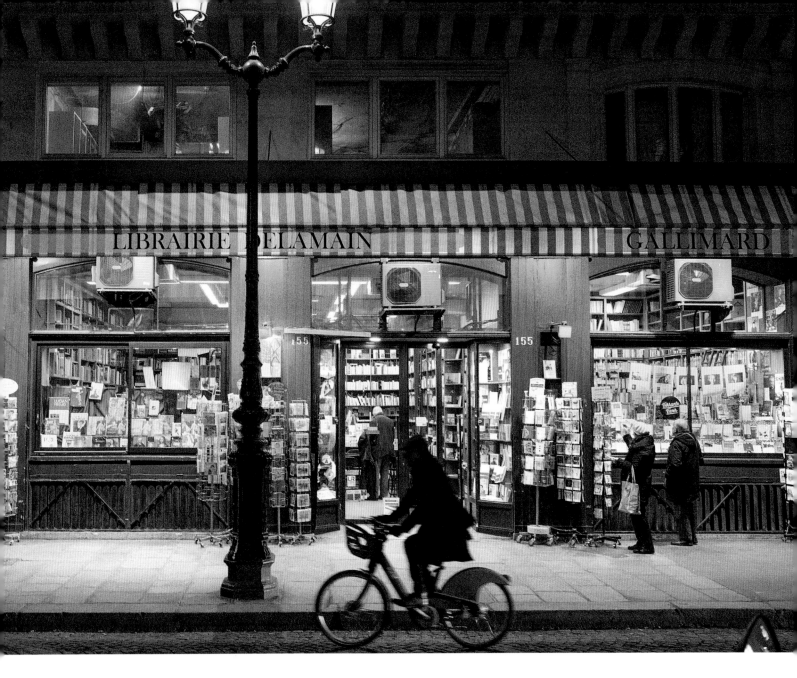

Galignani

224 Rue de Rivoli

Although this bookshop on Rue de Rivoli, in the first arrondissement, has been trading since 1801, its story dates back much further than that. All the way back to 1520, in fact, when Venetian publisher Simone Galignani printed his first book of Latin grammar. Towards the end of the sixteenth century, Galignani established its reputation in Italian bookmaking thanks to its version of *Geographica*, by Roman scientist Ptolemy, which proved enormously popular among academics.

A century later, the business was under the command of Giovanni Antonio Galignani, who relocated to Paris with his English wife Anne Parsons, and where, on Rue Vivienne, he opened a bookshop and reading room. His publishing business produced a daily newspaper for English speakers living on the continent, and successfully published books by British writers such as Lord Byron, William Wordsworth, William Thackeray and Walter Scott. By 1856, the business had settled at its current address, beneath the splendid arches on Rue de Rivoli.

While the newspaper and publishing house ceased its operations at the beginning of the twentieth century, it continued to champion English-language books. Until World War II, that is, when the occupying German forces banned books in the language of the enemy. Forced to adapt, Galignani opened a section devoted to art books instead, for which they are reputed to this day.

With Paris liberated at the end of the war, English-language books returned to the shelves. Nowadays there are three main departments in the bookshop: English, French and fine arts. Descendants of the original Galignani family are still running the company. 'Galignani combines sophistication with intellectual pleasure,' said bilingual magazine *France-Amerique* in a recent review. 'An invitation to an adventure suspended in time.'

OPPOSITE Galignani's is referenced in books by Turgenev, in Anthony Trollope's *Barchester Chronicles* and Thackeray's *Vanity Fair*.

RIGHT A plaque outside the bookshop in Rue de Rivoli celebrates Gaglinani's unique place in European publishing history.

THE FIRST
ENGLISH BOOKSHOP
—
ESTABLISHED
ON THE
CONTINENT

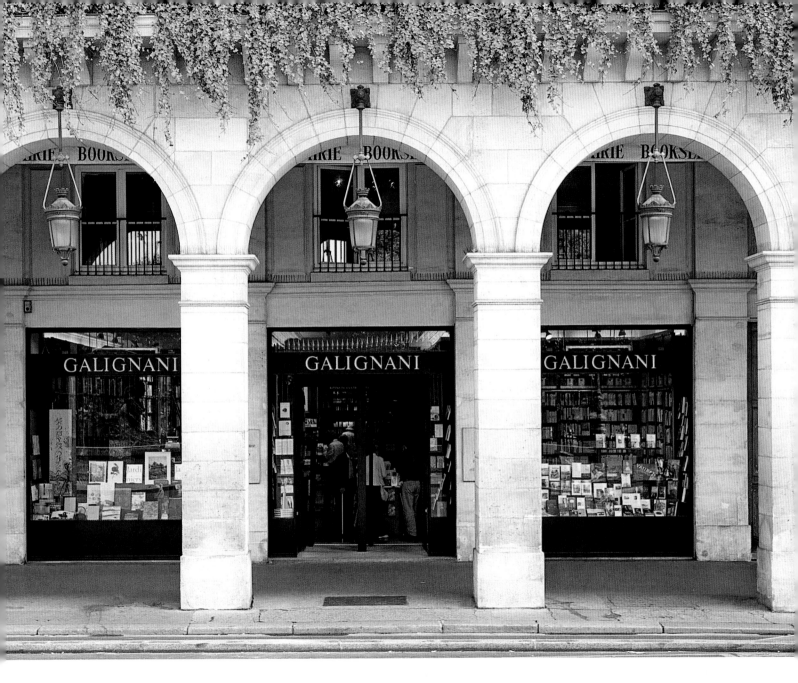

66

It is impossible for a Parisian to resist
the desire to flick through the old volumes
laid out by a bookseller.

99

Gérard de Nerval,
Les Filles du feu

Halle Saint-Pierre

2 Rue Ronsard

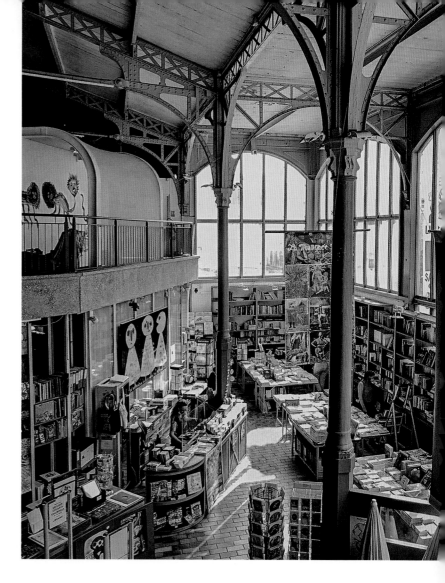

Combining a bookshop, museum, gallery and arts centre, Halle Saint-Pierre sits on Rue Ronsard, just south of Sacré-Coeur and Montmartre in a district known as Butte Montmartre. Before its current incarnation, the building housed a food market and then a school. Built in 1868, and featuring metal frames and expansive skylights, it was designed by a student of the architect Victor Baltard who also designed the vast Les Halles marketplace that once stood in the centre of the city.

Nowadays its most important feature is the Musée d'Art Naïf Max Fourny, a museum first established in 1986 by the publisher, collector and Bugatti racing driver of the same name. Exhibitions are staged regularly, focusing mainly on naïve art, folk art and 'outsider art'.

ABOVE AND RIGHT Located in Montmartre below the domes of Sacré-Coeur, the Halle Saint-Pierre was from the same design school as the nineteenth-century market Les Halles, demolished in 1971.

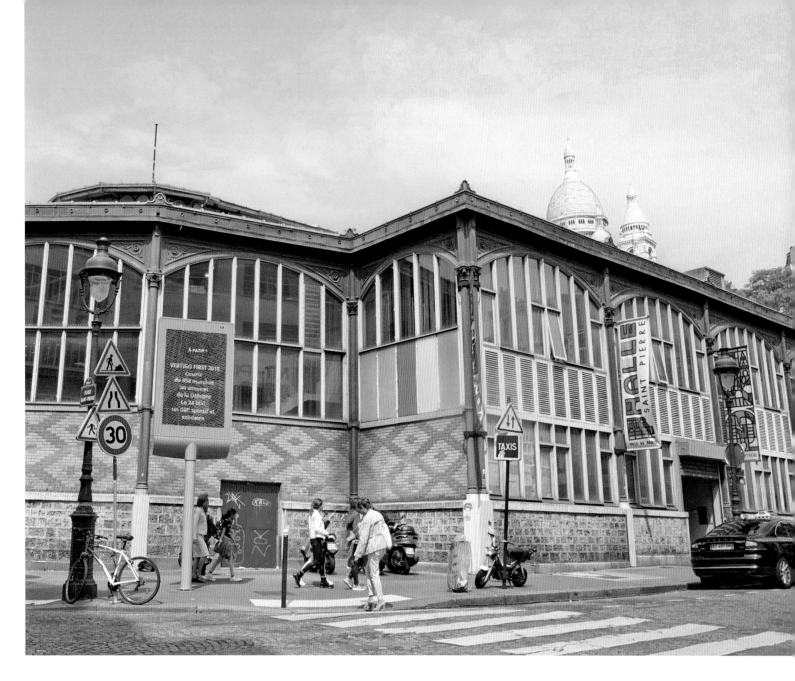

La Hune

16 Rue de l'Abbaye

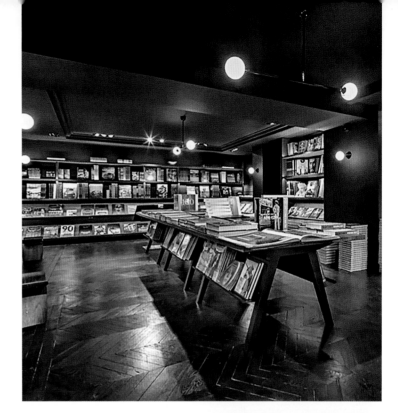

It was in the summer of 1944, while the Germans still occupied Paris, that three philosophy students from the Sorbonne first opened the bookshop known as La Hune (French for the topmast on a ship). It was given the name because of its position on the junction of two diagonal streets, which gave it the appearance of the prow of a ship.

After World War II had ended, two of those philosophy students – Bernard Gheerbrant and Jacqueline Lemunier – got married and decided to expand the bookshop with an art gallery and arts centre. Indeed, the current owners claim La Hune was the original bookshop/gallery.

By 1949 the store had outgrown its premises, requiring a relocation to Boulevard Saint-Germain, close to the famous cafés Les Deux Magots and Café de Flore. It was in La Hune that many writers, painters and photographers chose to meet. Several key painters and photographers also exhibited here, including Marcel Duchamp, René Magritte, Alexander Calder and Robert Doisneau. Pablo Picasso staged three exhibitions throughout the 1950s.

Over the ensuing decades, La Hune changed owners multiple times. In November 2017 it almost disappeared altogether when a fire ripped through the premises, injuring seven people in the process. Fortunately, a year later, after a complete renovation, the shop opened once more.

Nowadays it is a photography gallery run by publisher Yellow Korner, with a large selection of art books for sale. As the new owners explain: 'La Hune offers an ever richer and more dynamic artistic programme, doing its very best to make Paris the global capital of photography. The shop isn't afraid to reveal human emotions, and at the same time safeguard the heritage of the two traditions at its core: printed books and a deep love of photography.'

ABOVE AND OPPOSITE The new incarnation of La Hune bookshop combines gallery space with an impressive collection of books on photography.

RIGHT The earlier version of La Hune was packed wall-to-ceiling with literature.

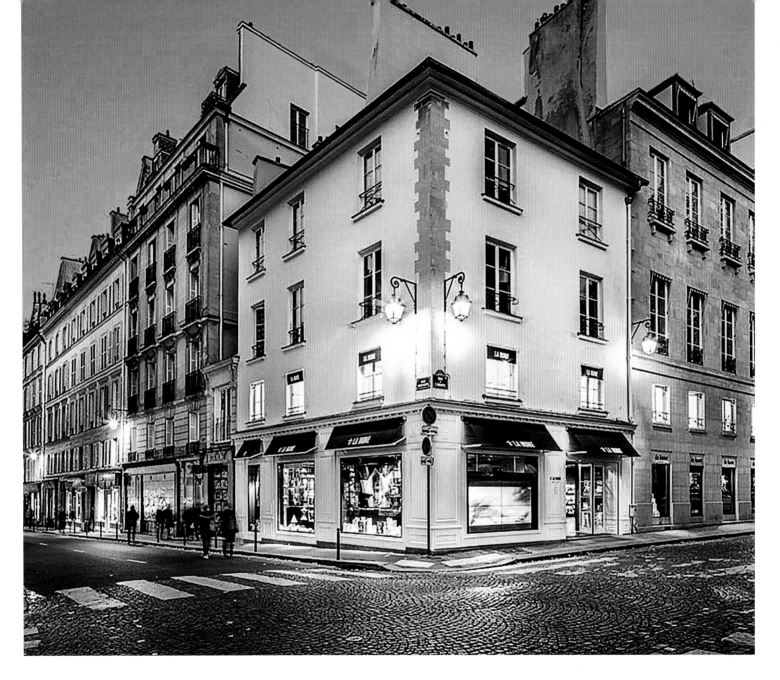

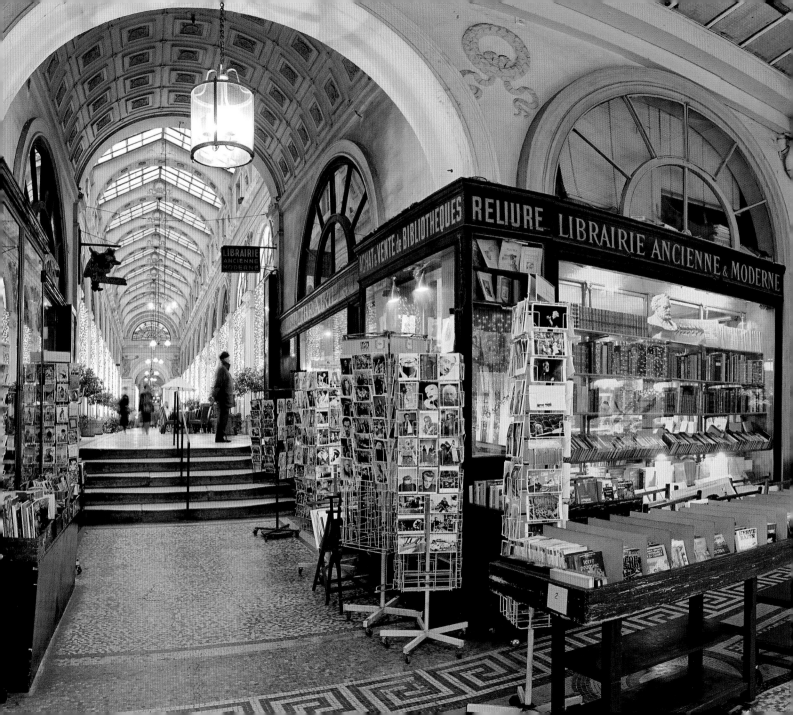

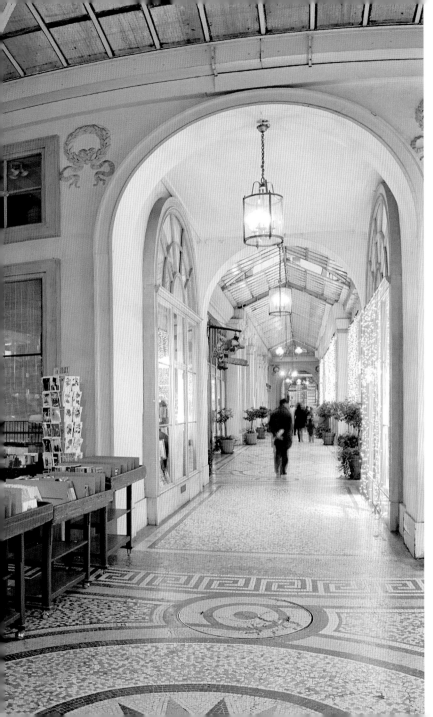

Librairie Jousseaume

45-46-47 Galerie Vivienne

There's something reassuringly old-fashioned about Librairie Jousseaume, near Palais-Royal. First established in 1826, this antiquarian bookshop located in a gorgeous covered arcade – one of Paris's prettiest – known as Galerie Vivienne, off Rue de la Banque, specialises in nineteenth- and twentieth-century books on history, poetry, theatre and music, as well as beautiful illustrated books, engravings, postcards and greetings cards.

As inspirational as the coveted books that occupy its interior is the décor that graces the arcade on its exterior. Designed by architect François-Jean Delannoy in 1823, it is neoclassical in style, and features a glass roof, a cupola and a mosaic floor. The arcade is nearly 180 metres long, but only three metres wide.

In its early years the bookshop was known as Librairie Petit-Siroux – a name still written above the shop window – but after it was acquired by the original Monsieur Jousseaume (great-grandfather of the current owner François Jousseaume) in 1890, it took on its current name. According to François, French novelists Colette and Jean Cocteau are former customers.

Split into two separate shops facing each other on a corner of the passage, Librairie Jousseaume is lined wall to ceiling with shelves that creak under, at last count, as many as 40,000 books, luring in passing browsers and regulars. On one side, a wooden spiral staircase twists up to a mezzanine stocked full of paperbacks.

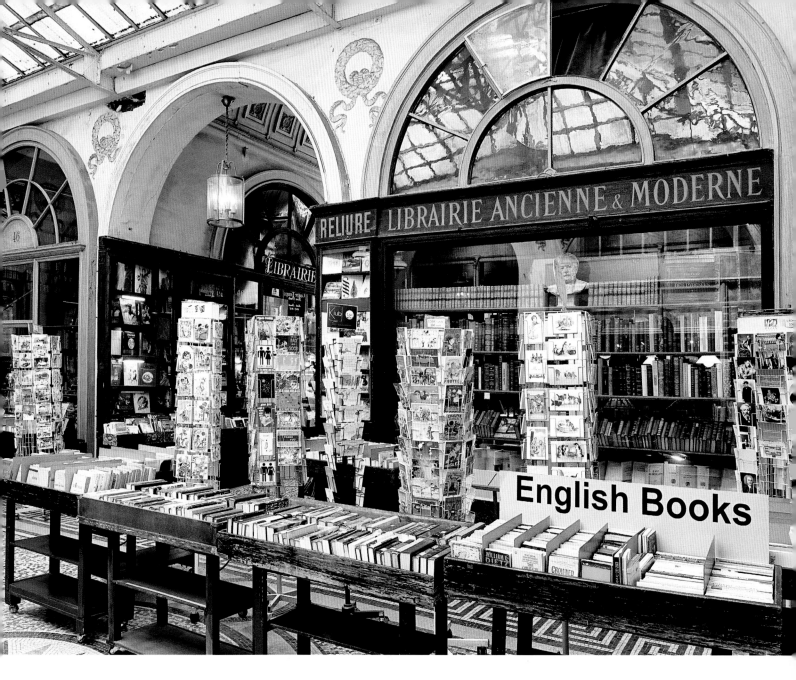

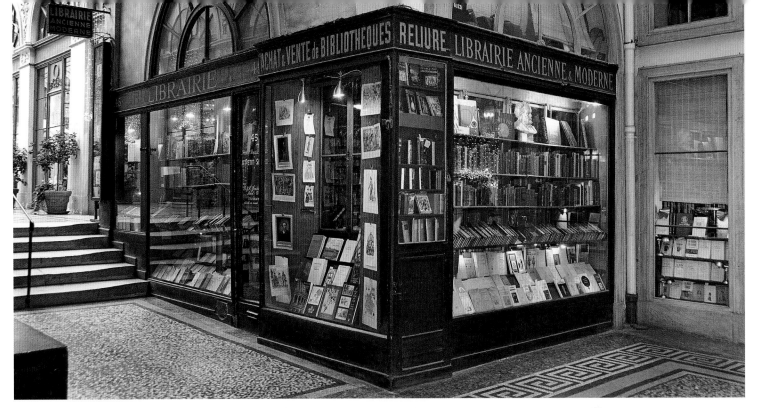

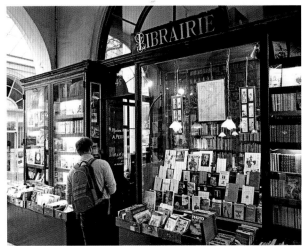

ABOVE Not many bookshops can look forward to celebrating their double century. For Jousseaume it will come in 2026.

LEFT Unlike other *librairies*, Jousseaume can put out their book boxes without fear of what Mark Twain described as 'Paris the drizzly, Paris the rainy'.

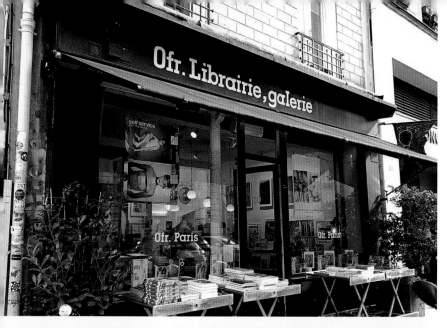

Ofr

20 Rue Dupetit-Thouars

Since opening the bookshop twenty-five years ago, siblings Alexandre and Marie Thumerelle have had to explain countless times what their name Ofr means. Back in the 1990s, when France still used their old currency, the brother-and-sister duo used to publish a newspaper, and Ofr was a nod to the price on the cover page – zero francs. Nowadays, though, the owners of this bookshop, gallery and events venue near Place de la République, have found new meaning in those three letters: 'Open for the O, free for the F, ready for the R,' is how they like to explain it.

There's no lack of variety here. There are regular concerts, exhibitions, book signings and magazine launches. Like many Parisian bookshop owners, Alexandre and Marie have a Parisian aloofness about the onslaught of digital technology in publishing. They don't have an official website – just an Instagram page – and at one time they even eschewed communication by email or telephone. 'We don't open emails because we want to meet the people we work with,' they once explained.

Since their original launch, in 1996, the sibling business has opened additional shops – some bricks and mortar, others just pop-up – all over the world, including in Copenhagen, Berlin, Seoul, Tokyo, New York City and California.

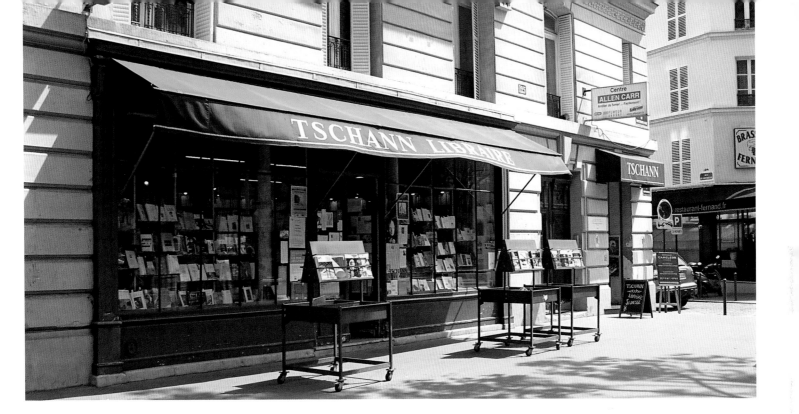

Tschann Librairie

125 Boulevard du Montparnasse

Founded in 1929 by Louis Tschann and his wife Marie-Louise Castex, this bookstore – originally at 84 Boulevard du Montparnasse, but now just down the road at 125, with three times the space – has a reputation for standing up for booksellers' rights. In the 1970s, the founder's daughter Marie-Madeleine Tschann was an advisor to politicians devising the Lang Law (*La loi Lang*), which limited price discounts on books, and came into effect in 1981. More recently co-owner Yannick Poirier has entered the battle between bricks-and-mortar bookstores and online traders. 'Bookstores are the conservators of a culture,' he once told news magazine *L'Obs*. 'They are the guardians of the freedom to think, to understand and therefore to choose.'

Marie-Madeleine once explained why her father first chose to open his famous bookshop: 'He became a bookseller out of taste. It was the era of the Surrealists, it was a crazier, less classic, livelier bookstore back then.'

"

Books, books, books. It was not that I read so much. I read and re-read the same ones. But all of them were necessary to me. Their presence, their smell, the letters of their titles, and the texture of their leather bindings.

Colette

"

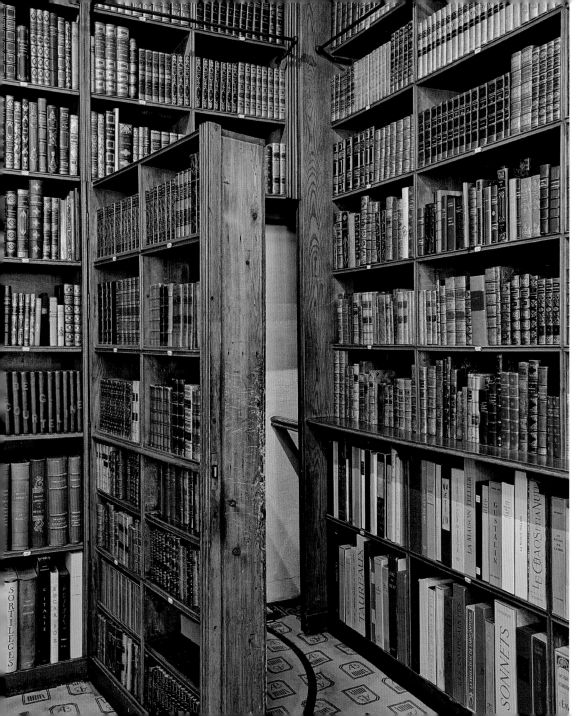

LEFT A revolving bookcase at Auguste Blaizot reveals access to the bookshop's hidden stairway.

Librairie du Passage

Passage Jouffroy

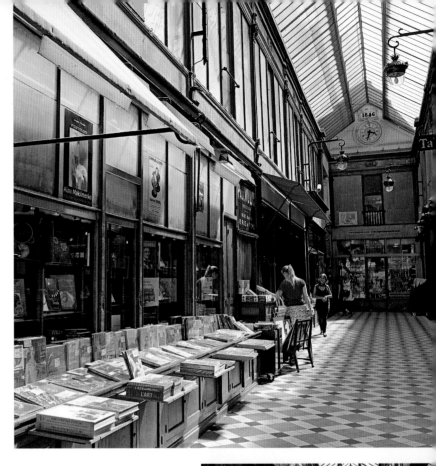

Tucked away in the wood-panelled Passage Jouffroy is the specialist Librairie du Passage. Jouffroy is one of the popular *passages couverts* built in the 1840s and completed in 1846 on three former housing plots. Along with the bookshop, which dates from the 1850s, there is the elegant Le Valentin tea rooms to enjoy and a toy shop which specialises in dolls and vintage toys. Perhaps the most famous inhabitant of the passage is Musée Grévin, the Paris wax museum created in the nineteenth century by *Le Gaulois* newspaper creators Alfred Grévin and Arthur Meyer, which still attracts 800,000 visitors a year.

The librairie shoehorns its stock into three themed levels, listing no less than 30,000 titles devoted to the fine arts with an enormous range of books on decorative arts, sculpture and design. These are expensive books, and staff are not particularly pleased when design students drop in and photograph pages or takes notes. It may be a *librairie* but it's clearly not a library.

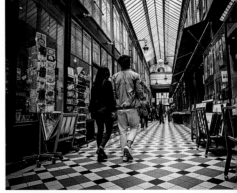

ABOVE Located off the Boulevard Montmartre, the 1850s bookshop has adopted modern ways and sells on Amazon's French website.

OPPOSITE The stairs lead up to the Grévin Wax Museum. You can see a wax figure of Ernest Hemingway, then buy his books next door.

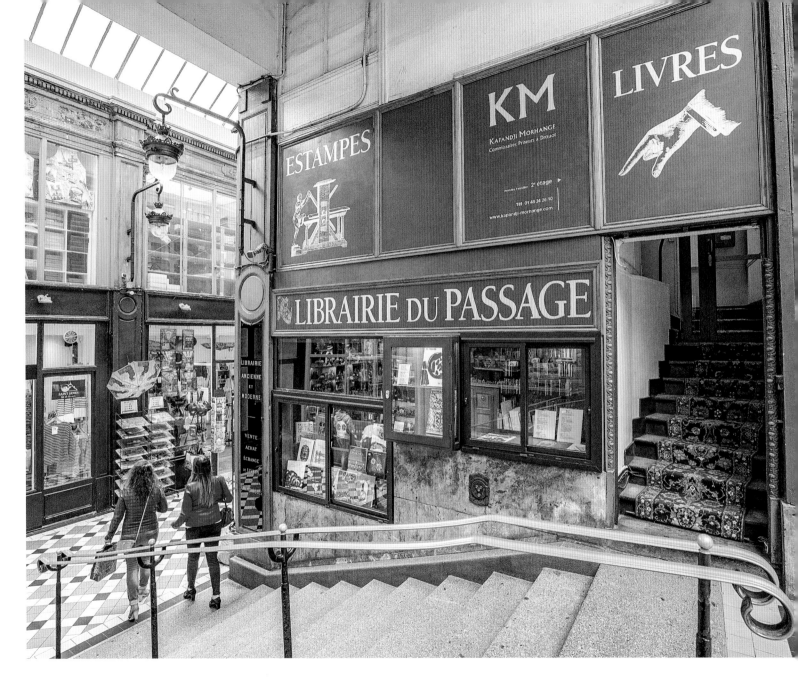

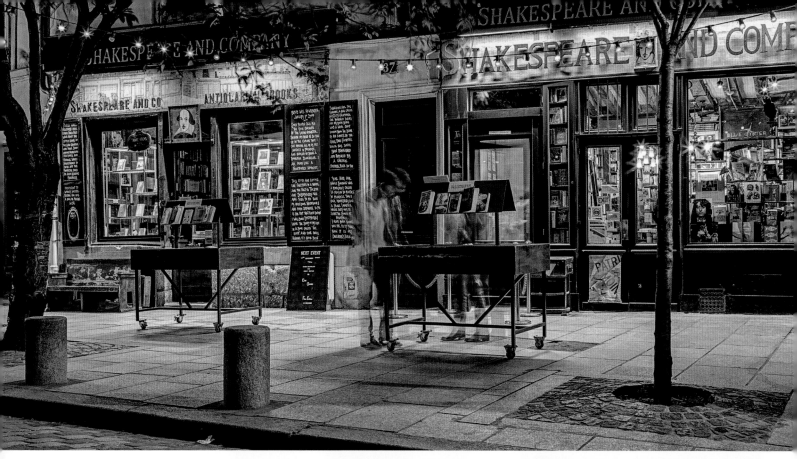

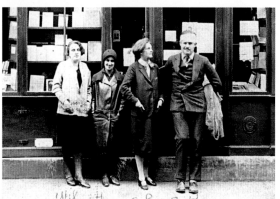

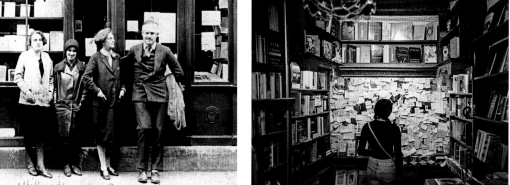

ABOVE George Whitman's bookshop only took on the Shakespeare and Co. name in 1964. Previously it was Le Mistral.

RIGHT To the right, Sylvia Beach stares at a heavily bandaged Ernest Hemingway outside 12 Rue de l'Odeon. 'Hem' pulled a skylight chain down on him to cause the injury.

FAR RIGHT The modern Shakespeare and Co. has a popular writers' noticeboard.

Shakespeare and Co.

37 Rue de la Bûcherie

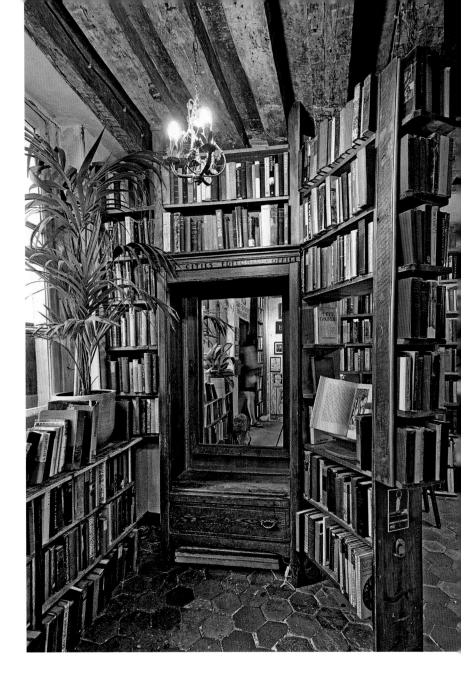

Encouraged by her French partner Adrienne Monnier, American Sylvia Beach opened her Paris bookshop, Shakespeare and Co., in 1919. Selling mostly British books, and offering a subscription library, she soon moved to 12 Rue de l'Odeon, right opposite Monnier's bookshop, La Maison des amis des livres, at No.7. The Grande Dame of the American cultural scene in Paris, Gertrude Stein, was the first subscriber to the lending library whose patrons were known as 'bunnies' after the French word *abonné*, for subscriber.

The shop attracted many Anglophones, including Ernest Hemingway, who wrote of Sylvia: 'No one that I ever knew was nicer to me.' Beach was also a great friend and supporter of James Joyce's work, and when the radical Irish writer could find no publisher for his novel *Ulysses* due to its perceived obscenity, Beach funded its publication in English. Monnier in turn published the first French edition, which was launched from her bookshop across the street.

But after the Wall Street crash, the depressed 1930s brought an exodus of Americans, and the shop struggled financially, a situation not helped by Joyce selling the American rights to *Ulysses* to Random House for $45,000 and pocketing the cash. André Gide and T.S. Eliot were

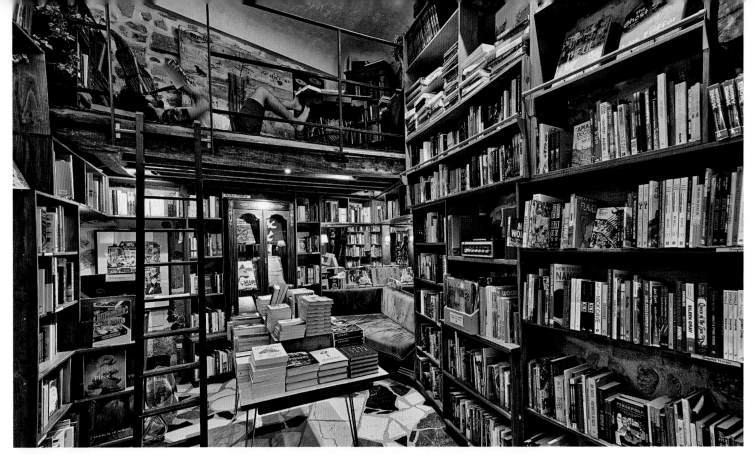

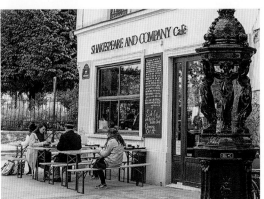

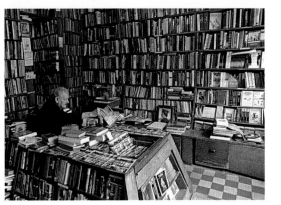

ABOVE The bookshop has a long tradition of giving accommodation to aspiring writers who work in the shop.

LEFT The eccentric George Whitman behind the desk in the 1980s.

FAR LEFT Now there is a Shakespeare and Co. café next door.

prominent in helping raise money for the struggling bookshop, which survived until 1941. During the German occupation, a Nazi officer came to the shop and demanded to buy Beach's personal copy of *Finnegan's Wake*, which was on display in the window. When she refused he threatened to return and confiscate the shop's contents. Overnight, with the help of friends, she moved the entire stock of 5,000 books to an empty apartment upstairs and the shop was closed for good.

After the war, an eccentric American ex-serviceman, George Whitman, used cash from the GI Bill to set up a bookshop at 37 Rue de la Bûcherie, close to Notre Dame. He called it Le Mistral and stocked it with his own large collection of books, along with some of the stock bought from Sylvia Beach. Whitman was a great admirer of Beach and continued the practice of hospitality that she and Monnier had begun, allowing aspiring writers to sleep in the shop overnight in return for help in the shop during the day (an arrangement vividly described in Jeremy Mercer's memoir *Books, Baguettes and Bedbugs*). Beach, who still lived at 12 Rue de l'Odeon, died suddenly in 1962, and two years later, on the 400th anniversary of Shakespeare's birth, George renamed his bookshop Shakespeare and Company. After his death in 2011, the bookshop was taken over by his daughter Sylvia Whitman – the name Sylvia was not coincidental – who along with husband David Delannet has expanded the business, which is still the lodestone of Parisian bookshops.

> " In the morning, I wake up with the sun in my face and a vision of chimney pots floating above the treetops in the garden of St Julien-le-Pauvre. At night I look out of the window at the illuminated spires of Notre Dame. This is the bookshop I have always dreamed of. "

George Whitman, 1951

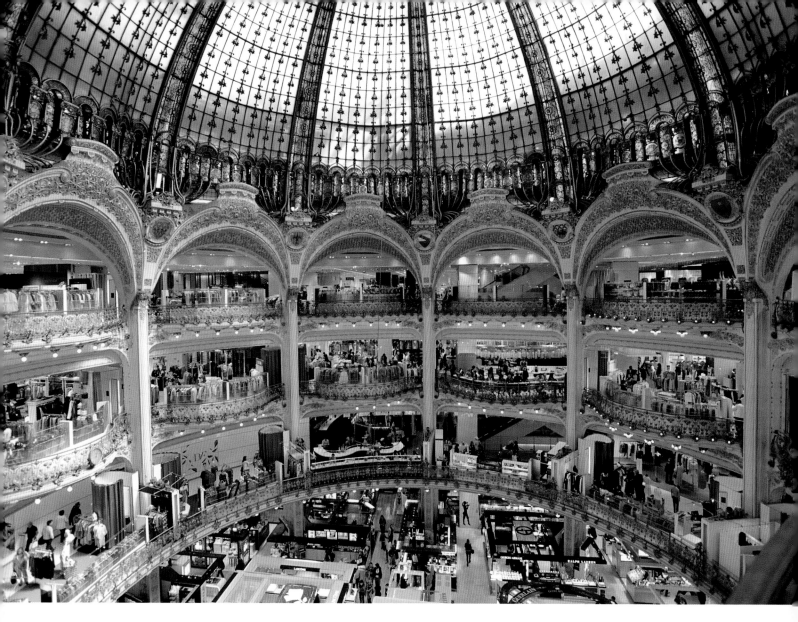

> **Whoever does not visit Paris regularly
> will never truly be elegant.**

Honoré de Balzac
Traité de la vie élégante

BOUQUINISTES

Right Bank & Left Bank

The bouquinistes along the Seine, the city's much-loved riverside booksellers, have been in business in one form or another since the sixteenth century. Back then, they were mainly itinerant salesmen to whom city authorities took a strong dislike since they were able to circumvent the censorship rules that constrained Paris's official booksellers. The protestant and political material they hawked attracted particular opprobrium.

By 1859, though, these stallholders were finally granted licences to sell books, (*bouquin* is a familiar French term for book). Eventually, for an annual fee, they were offered the famous green boxes that you still see today, lining long sections of the Seine – on the Right Bank, from Quai du Louvre to Pont Marie, and on the Left Bank, from Quai de la Tournelle to Quai Voltaire. As one Swiss writer famously said, Paris is the only city in the world where a river flows between two rows of books.

ABOVE Given the environmental hazards of an exterior bookstore, bouquiniste stock is often wrapped in plastic.

RIGHT Souvenirs are frowned upon and instead bouquinistes provide an astonishing miscellany of material.

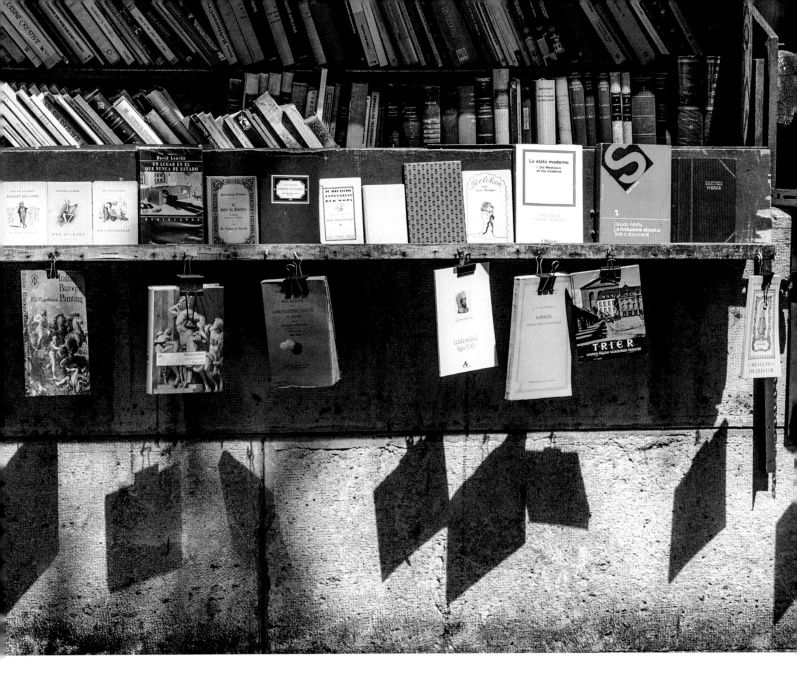

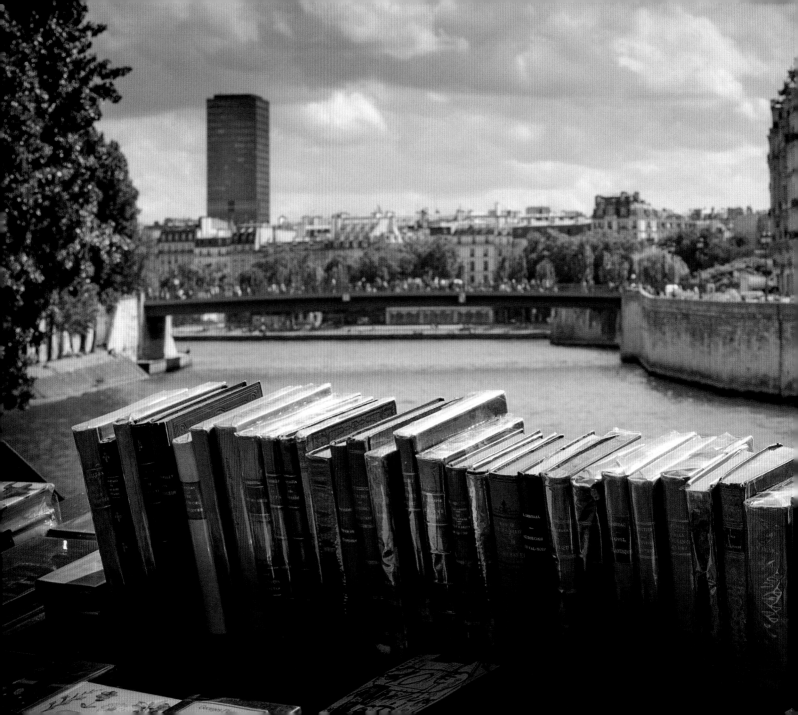

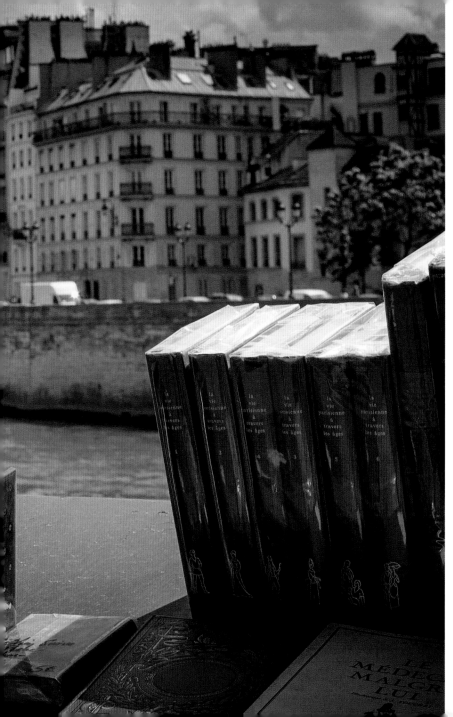

Defying the vagaries of the weather, the economy and the public appetite for reading, the bouquinistes still ply their wares today. And their famous boxes are still painted green – the same shade of green you see on Paris's columns and fountains. There are currently between 200 and 240 licensed sellers (depending on who you believe), each one permitted up to four boxes. In all, there are 900 boxes, spread out along three kilometres of riverbank, containing an estimated 300,000 volumes.

While the majority of their wares comprise second-hand and antiquarian books, you'll also find a treasure trove of old comics, magazines, journals, newspapers, maps, stamps, postcards, posters, trading cards and erotica. Some merchants even sell souvenirs, although the city authorities very much frown on this and limit the amount permitted. That's partly because in 1991 the banks of the Seine were granted UNESCO World Heritage Site status, and tacky trinkets are not in keeping with the overall image.

One of the more famous bouquinistes from recent history was Jean Genet, future novelist and author of *Notre-Dame-des-Fleurs*. During World War II, and in between stints in jail, he earned a crust by tending a bouquiniste bookstall on the Quai Saint-Michel belonging to a friend. In April 1942, still not published, he got chatting with a couple of customers from the publishing industry who offered to read his *Notre-Dame-des-Fleurs* manuscript. Bowled over, they showed it to Jean Cocteau who facilitated its publication in 1943.

ABOVE The bouquinistes opposite the Île de la Cité, with the dome of the commercial court to the left and a tower of the Conciergerie to the right.

OPPOSITE With the Notre Dame cathedral visible through the trees, this bouquiniste is doing a lively trade in 1960s rock posters.

So just how long can these famous bouquinistes last? There's no doubt that the competition of online second-hand bookselling poses a serious threat, while the global pandemic saw income disappear. But there's hope on the horizon. Thanks to a recent campaign by the Association Culturelle des Bouquinistes de Paris, the French Ministry of Culture has now added 'the traditions and savoir-faire of the quayside bouquinistes' to France's list of intangible cultural heritage.

One local politician was effusive in her praise of the booksellers. 'Bouquinistes contribute significantly to the literary soul of the City of Light,' said Florence Berthout, mayor of the fifth arrondissement. 'They perpetuate an intellectual and bibliophile tradition that is an essential component of the Parisian identity.'

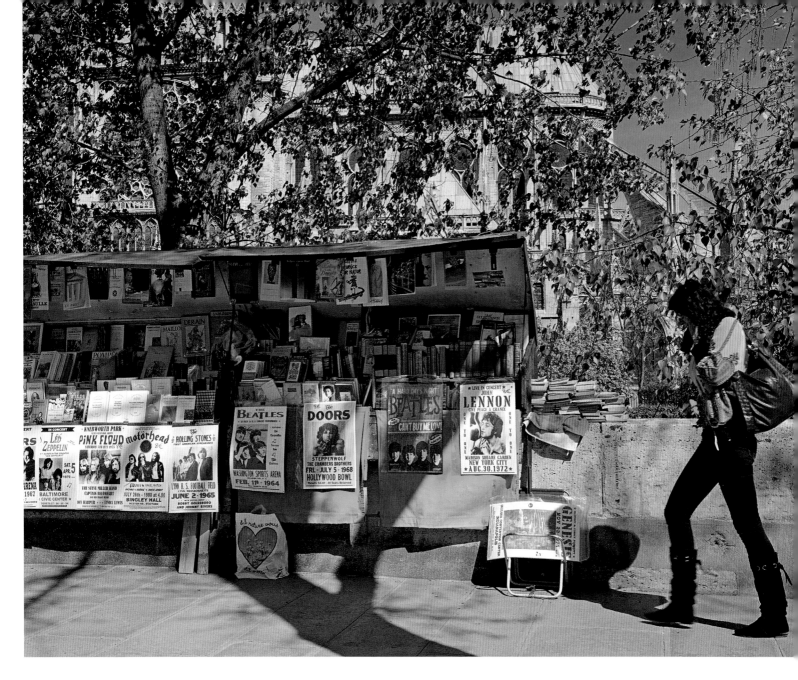

> **"**
>
> The bouquinistes along the quai open their boxes, and the yellow freshness or weariness of the books, the brown violet of the bindings, the more sovereign green of an album, all harmonise, count, take part in the whole and converge in consummate perfection.
>
> **"**
>
> Rainer Maria Rilke
> *Le bouquiniste et son chat*

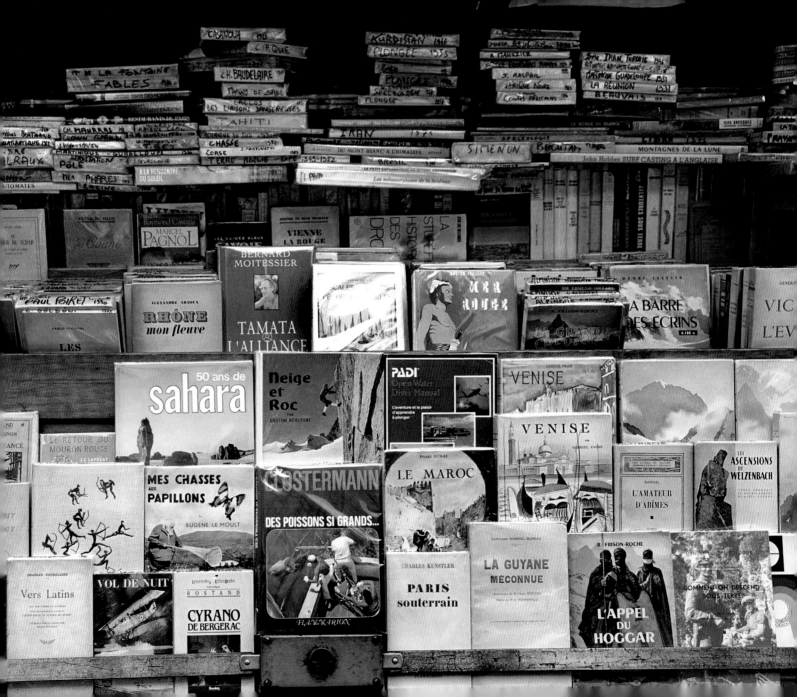

THEATRES

La Comédie-Française
Place Colette

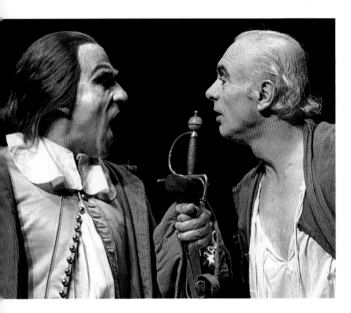

ABOVE Nicolas Lormeau (left), in the role of Leandre, and Gerard Giroudon (right), as Scapin, in the play *Les Fourberies de Scapin* by Molière at the Comédie-Française.

OPPOSITE The grand Salle Richelieu of the Comédie-Française in the Palais-Royal, on Place Colette.

Almost certainly the oldest active theatre company in the world, it was in August 1680 that La Comédie-Française was founded with a decree from King Louis XIV. It was formed by a merger of the only two acting troupes in Paris – the Hôtel de Bourgogne troupe and the Hôtel de Guenegaud Theatre troupe. The latter included former members of Molière's theatre company, which explains why the Comédie-Française is often known as La Maison de Molière. Unfortunately, France's greatest playwright had died seven years before it was established, his demise coming shortly after he was taken ill during a performance at the Palais-Royal.

Over the centuries, this state-owned institution has switched homes several times. It has survived schisms, revolution, imprisoned actors, foreign occupation, and a fire that ripped through the main theatre on Place Colette in March 1900. Actress and model Jane Henriot perished in that fire after trying to save her pet dog.

Nowadays the Comédie-Française has a repertoire of almost 3,500 plays, many of which are regularly performed at three different venues across Paris. The principal theatre is the grand Salle Richelieu in the Palais-Royal, on Place Colette, with its horseshoe-shaped auditorium and balconies. The interior was rebuilt after the ruinous 1900 fire, but a large part of the nineteenth-century façade was saved. Molière's aged armchair, in which the actor was taken ill during his final play (ironically *Le Malade Imaginaire*, or *The Hypochondriac*) is on display in the theatre foyer. The other two theatres are the Théâtre du Vieux-Colombier, on Rue du Vieux-Colombier, in the sixth arrondissement, and Studio-Théâtre, on Rue de Rivoli, in the first arrondissement.

The company pay tribute to Molière every year on January 15th, the date of the great playwright's christening. In 2022, to celebrate the 400th anniversary of his birth year, the Comédie-Française staged a special production of *Tartuffe*, his Catholic-church-baiting satire.

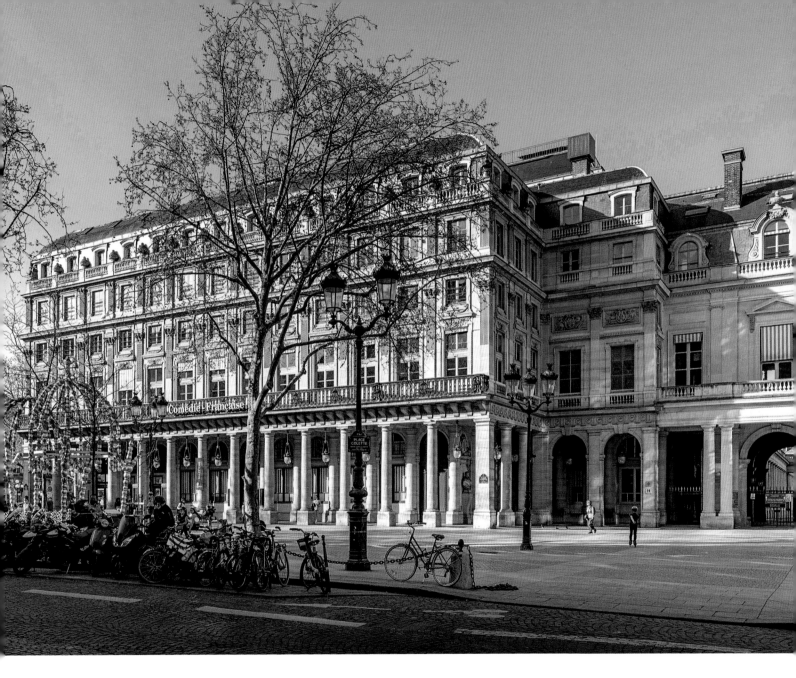

L'Odéon-Théâtre de l'Europe

2 Rue Corneille

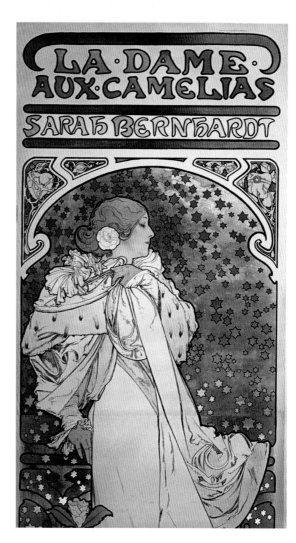

The original Théâtre de l'Odéon – since 1990 it has been known as L'Odéon-Théâtre de l'Europe – was a neoclassical design by architects Charles de Wailly and Marie-Joseph Peyre, and was constructed in 1782 for the Comédie-Française. Marie-Antoinette was present at its opening in April of that year. The theatre earned its place in literary history largely thanks to the plays of Beaumarchais, the twice widowed playwright who had penned the original *Barber of Seville* in 1775. While that drama was used as the libretto for Rossini's opera, it was the play Beaumarchais wrote for the Odéon that would become a success for Mozart: *The Marriage of Figaro* (its French name *La Folle Journée, ou Le Mariage de Figaro*), received its premiere there in 1784. This story, which hinges around valet Figaro's attempts to prevent the Count Almaviva from stealing away his fiancée Suzanne, took a long while to reach its audience, however. Beaumarchais first penned it in 1778, when it was originally banned because of its criticism of aristocratic privilege. On its debut six years later it was a rousing success, though. With its portrayal of class conflict, many later considered it a presage of the French Revolution.

In 1799, the original playhouse was destroyed in that perennial hazard of all theatres, fire. In fact its second incarnation, designed by Jean Chalgrin (architect of the Arc de Triomphe) stood for an even shorter time, opening in 1808 and succumbing to flames in 1818. The third incarnation, which survives to this day, was the place where Sarah Bernhardt made her name as an actress. In her memoirs she wrote that it was the Paris theatre she loved the most: 'I remember my few months at the Comédie-Française. That little world was stiff, gossipy, jealous. I remember my few months at the Gymnase. There they talked only about dresses and hats, and chattered about a hundred things that had nothing to do with art. At the Odéon, I was happy. We thought only of putting on plays. We rehearsed mornings, afternoons, all the time. I adored that.'

ABOVE Sarah Bernhardt established her reputation at L'Odéon. *La Dame aux Camelias* would become one of her defining roles.

RIGHT The roads leading to Place de l'Odéon are all named after playwrights: Rue Corneille, Rue Racine, Rue Crébillon, Rue Regnard and Rue Rotrou.

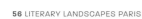

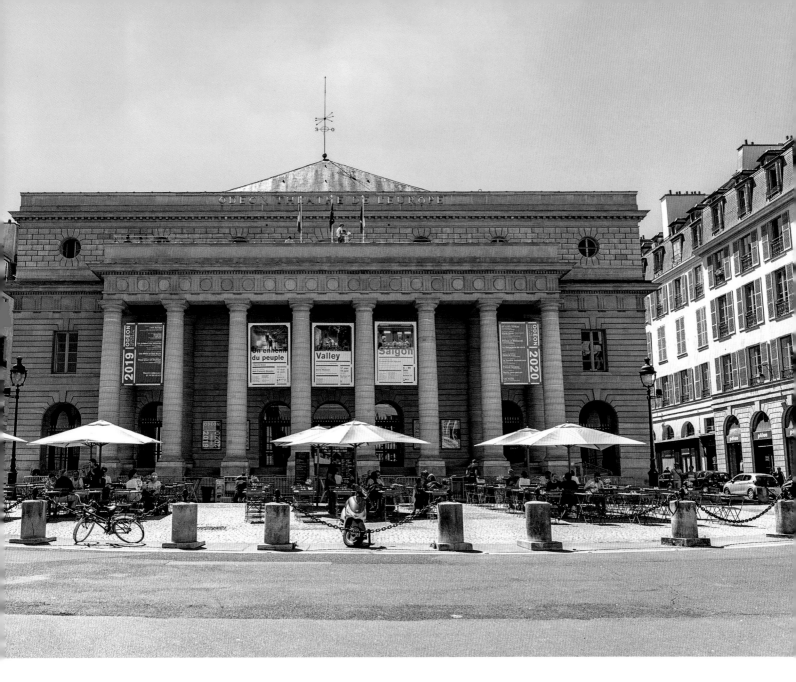

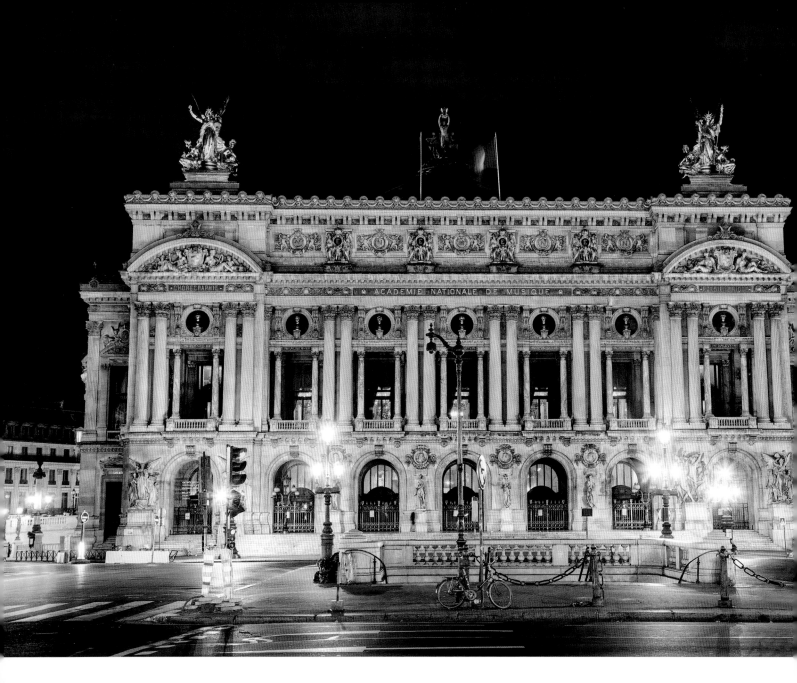

Palais Garnier

Place de l'Opéra

It was May 1896, and soprano Rose Caron had just completed her aria at the end of Act One of Etienne-Joseph Floquet's opera *Hellé*. Suddenly there was a deafening crash as one of the stage chandeliers' counterweights dropped down from the roof into the audience, killing one spectator and injuring several others. It turned out a fire in the opera house roof had burnt through supporting wires.

Parisian journalist Gaston Leroux heard about this tragic accident and later used it as inspiration for his 1910 Gothic novel *Le Fantôme de l'Opéra* (*The Phantom of the Opera*), the famous story about a grotesquely disfigured conjurer who terrorises the opera company at Palais Garnier. As with Dickens' great works, the story was first published in serial form, in *Le Gaulois* newspaper from September 1909 to January 1910, and subsequently released as a novel. Several stage and screen adaptations followed, along with the Andrew Lloyd Webber musical, all contributing to the opera house's international renown.

Today, the Palais Garnier is home to the Opéra National de Paris, on Place de l'Opéra, in the ninth arrondissement, with an auditorium that holds close to two thousand. Its architecture is in the highly decorative Second Empire style, with ornate marble friezes and lavish statues and busts. The interiors, meanwhile, boast sumptuous Baroque features, with plenty of mosaics, frescoes and gold leaf, as well as a central seven-tonne bronze-and-crystal chandelier in the auditorium – the counterweight of which played such a key role in the building's history.

OPPOSITE Charles Garnier designed the opulent Opéra de Paris, which was built between 1861 and 1875.

ABOVE Such was the grandeur of the building that it soon became known as the Palais Garnier. Today, it hosts mostly ballet, with operas at the more acoustically sympathetic Opéra Bastille.

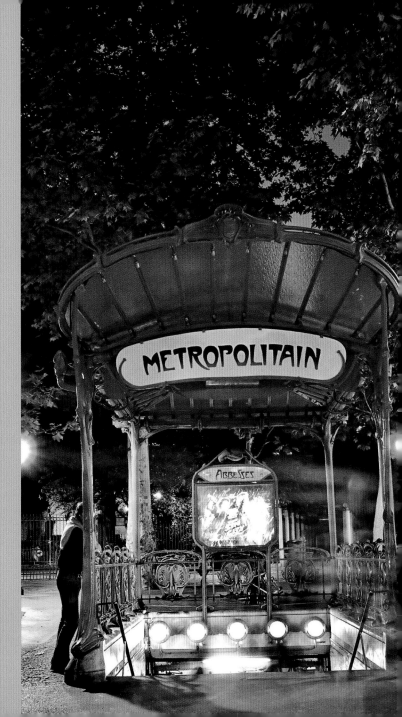

> **"**
>
> He who contemplates
> the depths of Paris is
> seized with vertigo.
> Nothing is more fantastic.
> Nothing is more tragic.
> Nothing is more sublime.
>
> **"**
>
> Victor Hugo

RIGHT The classical Hector Guimard-designed Métro entrance at Abbesses in Montmartre, a station made famous by the film *Amélie*.

"

But Paris is a true ocean. Take a sounding there, you will never know its depth. Go through it, describe it: whatever care you take to go through it, to describe it; however numerous and interested the explorers of this sea may be, there will always be a virgin place, an unknown lair, flowers, pearls, monsters, something unheard of, forgotten by literary divers.

Honoré de Balzac,
Le Père Goriot

"

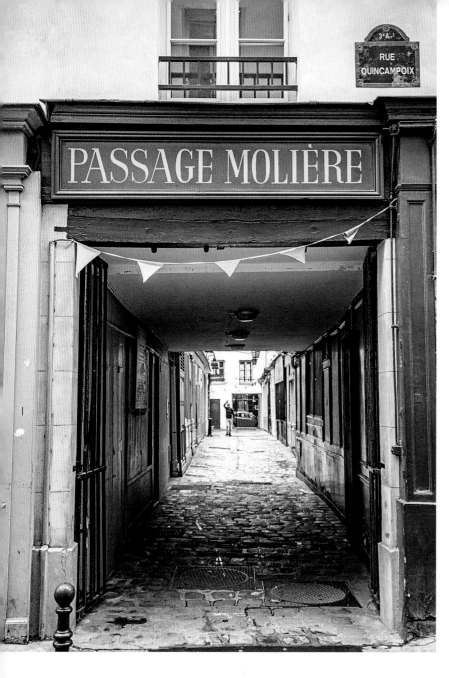

Maison de la Poésie – Scène Littéraire

Passage Molière

This theatre and arts centre, dedicated to the performance of live poetry, was first established in 1983, by the mayor of Paris and future French president Jacques Chirac. Twelve years later it moved to its current home in the Théâtre Molière, on Passage Molière, in the third arrondissement.

During the French Revolution, this venerable building witnessed more than a little controversy. It was a revolutionary called Jean François Boursault-Malherbe who first opened the Théâtre Molière in June 1791 (just two years after the Storming of the Bastille). Molière's satirical play of 1666, *Le Misanthrope*, which exposed the hypocrisies of French aristocrats was the first play produced here alongside other revolutionary fare such as *La Ligue des Fanatiques et des Tyrans* (*The League of Fanatics and Tyrants*) by former army general Charles-Philippe Ronsin, who later met his end beneath the guillotine.

The theatre changed names many times over those early years, as did the Passage Molière – which at one time was renamed Passage des Sans-Culottes. Soon it ceased to be a theatre at all, at times serving as a ballroom, a banquet room, a concert hall and a meeting room. By the mid-1800s it had fallen into disrepute and disrepair, rented out to merchants and shopkeepers.

In 1974 the city purchased the building and gave it a total renovation, restoring its eighteenth-century features. By 1995, Maison de la Poésie had moved in. Nowadays it stages poetry recitals, exhibitions and workshops across two stages.

ABOVE The blue sign to the left marks the entrance to Maison de la Poësie.

LEFT Billed as 'one of Paris's best kept secrets' the ancient passage has a collection of interesting shops and small cafés.

OPPOSITE The entrance to Passage Molière on Rue Quincampoix, one of the medieval streets of Paris that Baron Haussmann failed to sweep away.

Théâtre des Variétés

Boulevard Montmartre

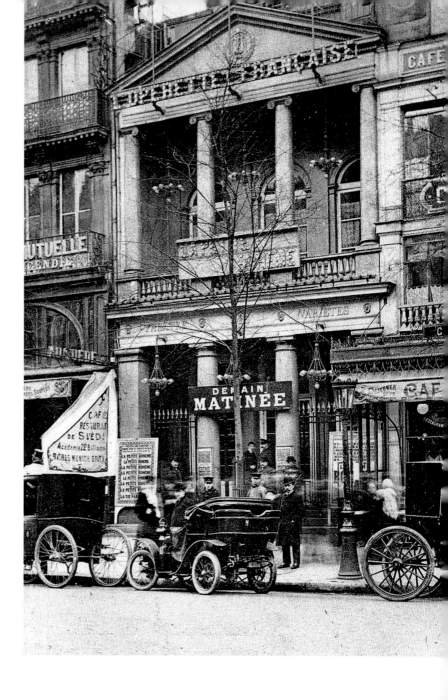

Napoleon Bonaparte himself played a role in the establishment of this theatre, on Boulevard Montmartre, in the second arrondissement. In the early 1800s, actress and theatre director Marguerite Brunet (better known by her stage name Mademoiselle Montansier) was in charge of a theatre company known as Variétés, which used to ply its trade at the Théâtre du Palais-Royal. Ordered to leave the theatre, Montansier got very upset, but managed to gain an audience with the emperor, who granted her and her troupe a certain protection.

The new Théâtre des Variétés soon followed, its opening night in June 1807 staging a vaudeville by Marc-Antoine Désaugiers, called *Le Panorama de Momus*, which by all accounts was a rousing success.

Over the years, some of Théâtre des Variétés' more successful productions have included plays by Alexandre Dumas, Jacques Offenbach, Flers & Caillavet and Marcel Pagnol. The theatre is still enormously popular among Parisians.

Perhaps its most famous production of all is actually a fictitious one. For his 1880 novel *Nana*, Émile Zola set the opening scene at the Théâtre des Variétés. He used the opportunity to present all the key fictitious characters from his story, including Nana herself, at the opening night of an operetta called *La Blonde Vénus*. And it's Nana who famously steals the show, not by virtue of her acting talent (for she had none) but through her captivating sexuality. In the final act she appears on stage virtually naked.

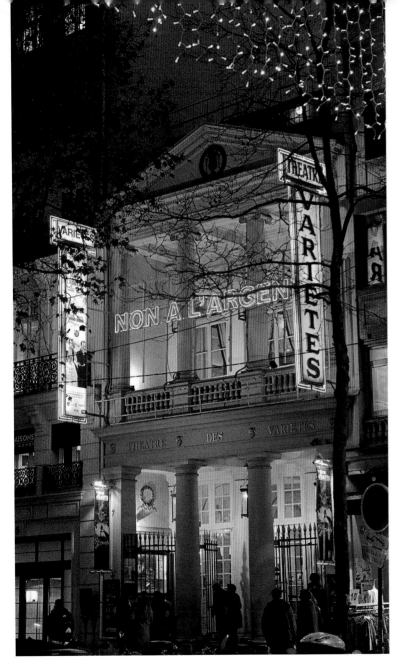

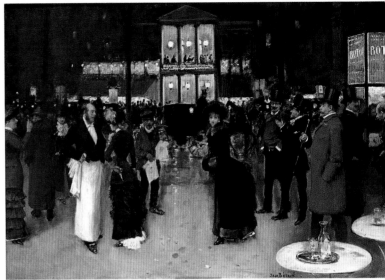

ABOVE Artist Jean Béraud made a career of depicting the life of Paris society. This is his painting of the Boulevard Montmartre at night with the illuminated colonnades of the Variétés as a backdrop.

LEFT The façade of the theatre has changed little in two hundred years.

OPPOSITE A turn-of-the-century photo of the Variétés. In 1907, before the establishment of cinemas, it premiered the first feature-length European film, *L'Enfant prodigue*.

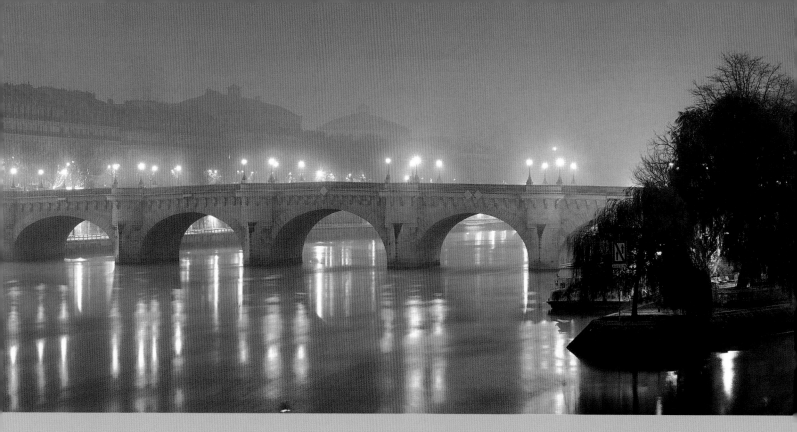

> I love to watch the fine mist of the night come on,
> The windows and the stars illumined, one by one,
> The rivers of dark smoke pour upward lazily,
> And the moon rise and turn them silver. I shall see

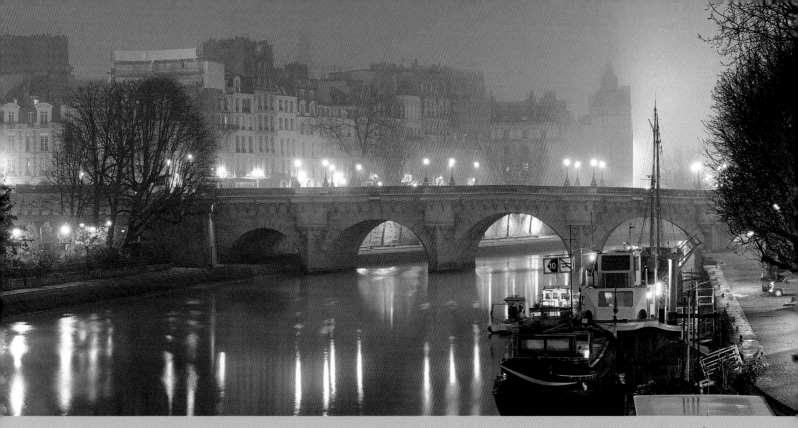

ABOVE Mist swirling over the Île de la Cité, the Seine River and Pont Neuf bridge.

The springs, the summers, and the autumns slowly pass;
And when old Winter puts his blank face to the glass,
I shall close all my shutters, pull the curtains tight,
And build me stately palaces by candlelight.

Charles Baudelaire, *Les Fleurs du Mal*

"

James Baldwin

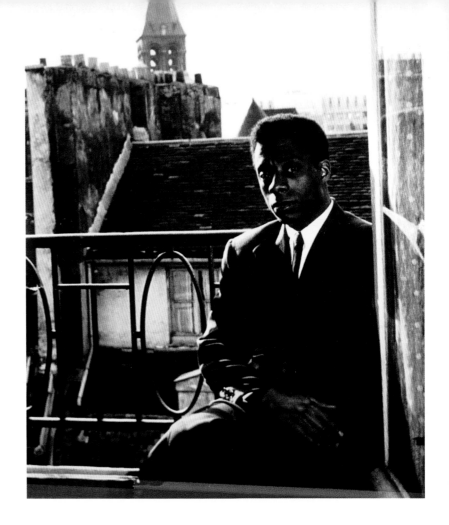

James Baldwin had two prejudices to contend with. He was a gay black man in the US and needed a place to write. He passed up the chance to go to the newly founded Israel and instead travelled to Paris in 1948, where Richard Wright found him cheap accommodation on the Boulevard Saint-Michel. Wright made introductions and helped get Baldwin established in a city that he loved at first, until the romance eventually wore off – abetted by cold winters in unheated rooms, accumulated Paris grime and being constantly short of money. Indeed, Baldwin's experience was closest to George Orwell's; despite his limited French he would often hang out with Algerians, where scratching a living was the order of the day. He moved to the even cheaper Hôtel Verneuil in Rue de Verneuil, where a cold turned into pneumonia and he was nursed back to health over three months by the aged matriarch. Madame Dumont had to, 'climb five flights of stairs every morning to make sure I was kept alive' and Baldwin was astonished by her kindness.

He did most of his early writing in the warmth of the Brasserie Lipp or upstairs at Café de Flore, which was a regular meeting place for gay men. Despite a falling out with Wright after publishing his critical essay 'Everybody's Protest Novel', gradually his writing career took off, with *Go Tell It on*

ABOVE Baldwin returned to the US in the 1960s to help the Civil Rights movement, but returned to France in 1970.

ABOVE RIGHT Hôtel Verneuil was just a few metres away from Serge Gainsbourg's Paris home, which today is a place of pilgrimage.

RIGHT Café de Flore was both an office for Baldwin and a rendezvous.

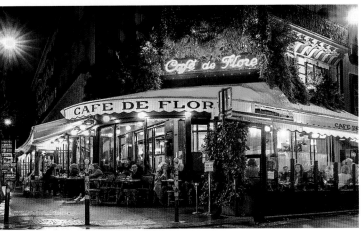

the Mountain published in 1953. His financial situation barely improved and he was forced to move to a small room at the inappropriately named Grand Hôtel du Bac, which would become the source for his 1956 novel *Giovanni's Room*, about a gay love affair in Paris between an American and an Italian barman. A large part of the novel would be written in Le Select café, and many of the venues in which he wrote would appear in later novels.

By the late 1950s he could not ignore the growing Civil Rights movement and that, along with Parisian plumbing, sent him home in 1957. He would return to settle in the south of France, at Saint-Paul-de-Vence, in 1970. After his death in 1987, and despite being awarded the *Légion d'Honneur* by the French government, the local mayor declared that 'nobody has ever heard of James Baldwin' and allowed his house, Chez Baldwin, to be razed and redeveloped as an apartment block.

Honoré de Balzac

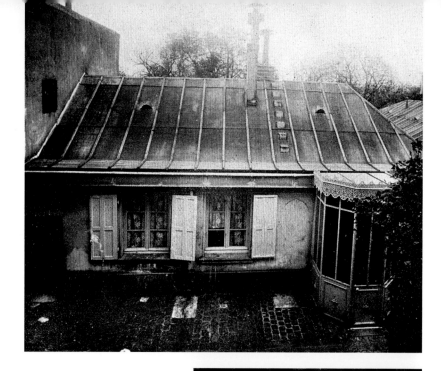

Just across the Seine from the Eiffel Tower, on Rue Raynouard, is a pretty three-storey spa house where the novelist Honoré de Balzac lived and worked in the 1840s, editing his magnum opus, *La Comédie Humaine* – a vast body of work consisting of no less than 91 interlinked novels and stories, covering post-Napoleonic life in France, written in the realist style. Nowadays the house is called Maison de Balzac, a museum dedicated to the industrious writer, and featuring letters, manuscripts, prints, portraits and memorabilia.

His career was not the easiest of journeys. Deeply in debt for much of his life and hounded by creditors, he holed up on Rue Raynouard under a false name for seven years, working all day and often through the night in an effort to complete his great work. Among the most famous of his novels were *Le Père Goriot*, *Illusions Perdues* and *La Cousine Bette*. Rumours have it he was fuelled by up to 50 cups of tar-like coffee every day – a habit which surely hastened his demise at the age of 51.

Born in Tours, in the middle of France, Balzac moved to Paris in 1816, where he studied at the Sorbonne. His parents wanted him to work in law, but he was determined to become a writer, eventually moving into a run-down garret near the Bastille.

After learning his craft with a series of little-respected potboilers, he finally got into his stride, producing the first of his *La Comédie Humaine* novels in the early 1830s. Rue Cassini, in the 14th arrondissement, was one of his homes,

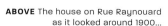

ABOVE The house on Rue Raynouard as it looked around 1900…

OPPOSITE …and the house as it looks today, transformed into the Balzac museum.

RIGHT Louis Boulanger's portrait of Balzac from 1836 shows him wearing his famous monk's cowl.

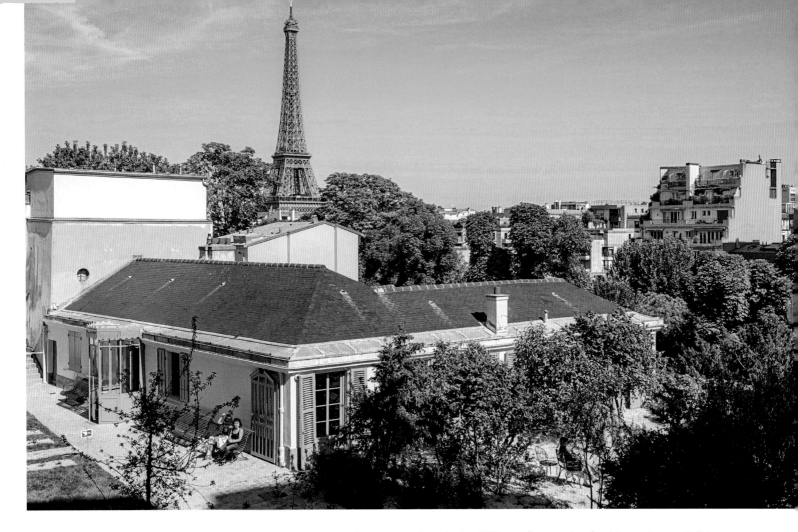

and later Rue des Batailles (now Avenue d'Iéna). He constantly owed money, however, and the threat of debtor's prison loomed over him. It was at Rue d'Iéna that he attempted to hoodwink his creditors by leaving the building's façade and lower floors shabby and undecorated. Renting under a false name, he required visitors to call out special passwords before they were permitted into his luxurious quarters on the third floor.

By 1840 he was in his house on Rue Raynouard (then Rue Basse). Guests also required passwords to enter this residence.

Balzac died in 1850, just five months after his marriage to Polish noblewoman Ewelina Hanska, and was buried at Père Lachaise cemetery. Forty years after his death, the great sculptor Auguste Rodin created his three-metre-tall *Monument to Balzac*. Initially rejected, it wasn't cast until just before World War II. It can now be found on the junction of Boulevard Raspail and Boulevard du Montparnasse, in the sixth arrondissement.

The Bastille

When it comes to pre-Revolutionary despotism, the Paris fortress and prison known as The Bastille could not be more symbolic. The day it was famously stormed by revolutionaries – 14 July 1789 – has been celebrated as France's national day ever since.

As the principal state prison, it was home to many a hapless writer, usually incarcerated there after upsetting the authorities – even the King himself – in print. Literary inmates included Voltaire, who was falsely accused of penning a satirical verse on the Prince Regent, Philippe D'Orléans. In fact, it was while in prison that Voltaire devised his pen name, his real one being François-Marie Arouet. Shortly afterwards, the very same royal also imprisoned memoir writer Madame de Staal de Launay for plotting to have him overthrown.

Perhaps the most infamous writer of all, however, to occupy The Bastille at his majesty's pleasure was the Marquis de Sade – philosopher, pornographer and libertine – who spent five years there, right until the storming in 1789 and its subsequent demolition. During this time he wrote his notorious novel *The 120 Days of Sodom*, the manuscript of which he kept hidden in the walls of his cell. As the rioters were beating down the prison doors, the marquis was rapidly relocated by his jailers to a nearby lunatic asylum, his 12-metre-long manuscript left behind. He was distraught, thinking it lost forever. It was finally published almost a century after his death.

A prison as notorious as The Bastille was sure to feature in plenty of novels. Sure enough, in the third of his d'Artagnan Romances, Alexandre Dumas relates the story of the *Man in the Iron Mask*, a real-life but unidentified Bastille prisoner incarcerated during Louis XIV's reign. And in Charles Dickens' revolution-era novel *A Tale of Two Cities*, a French nobleman is saved from the guillotine when an English barrister switches places while visiting him in The Bastille.

ABOVE The outline of the prison walls are shown on a neighbouring building and embedded in stones on the Place.

RIGHT Place de la Bastille with the July Column and the Opéra Bastille beyond.

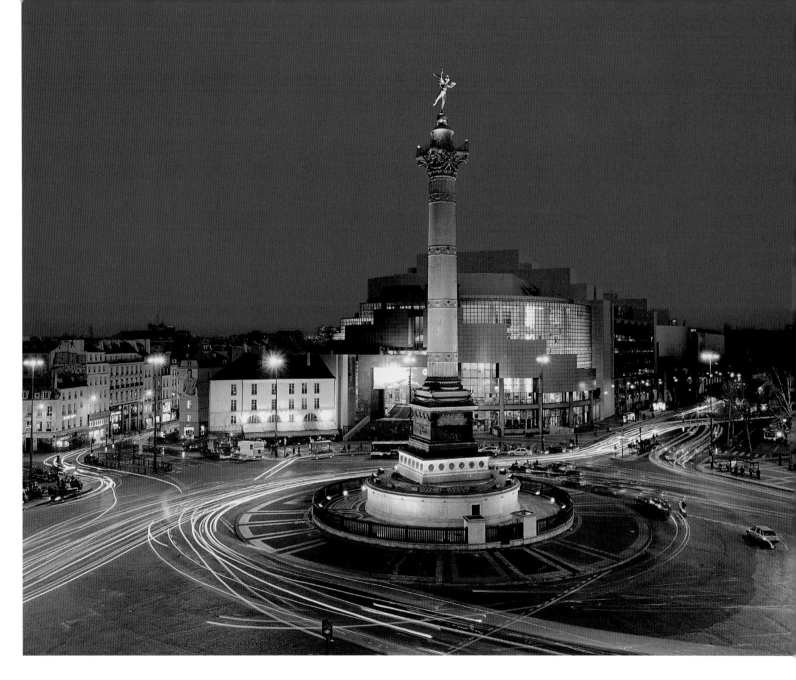

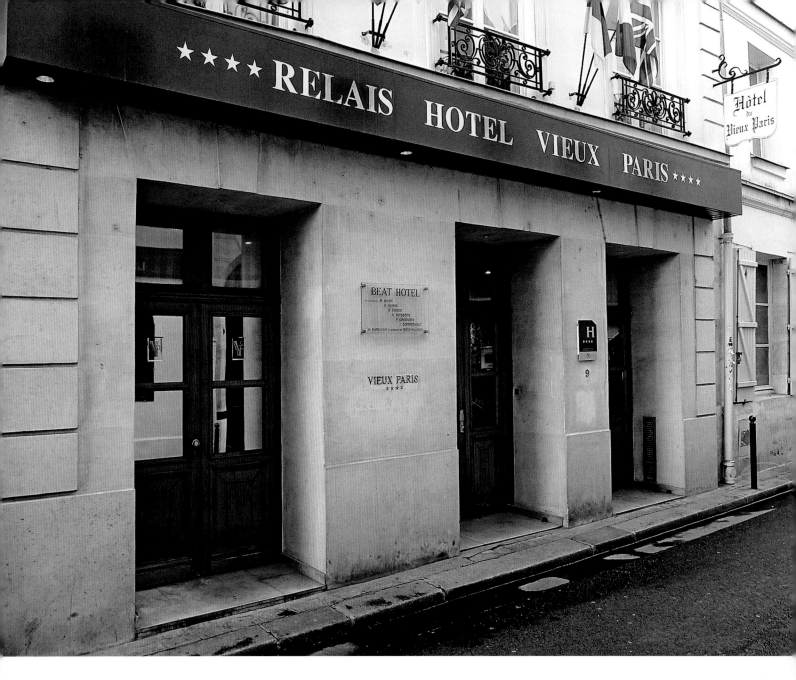

Beat Hotel

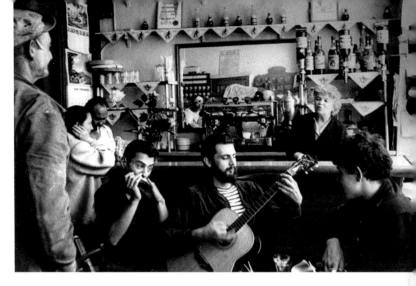

Back in the mid-20th century, the Beat Hotel, on Rue Gît-le-Coeur, was a veritable flea-pit. For well under a dollar a night, down-at-heel novelists and poets would shack up for months at a time, hoping to glean some sort of inspiration for their next oeuvre. The interior was famously dingy, with guests' bed linen rarely washed, hot water at weekends only, and a bathtub on the ground floor that had to be reserved in advance.

It was most famous for being home to the American writers of the Beat Generation, a literary movement defined by unorthodox narratives and plenty of references to sex and drugs. Gregory Corso was one of the first to benefit from its shoddy surroundings, in the late 1950s. There soon followed the likes of Allen Ginsberg, Peter Orlovsky, Derek Raymond, Harold Norse, Sinclair Beiles and William Burroughs. The hotel proprietress, Madame Rachou, was occasionally known to let her clients off the rent in return for free paintings and manuscripts.

While living at the Beat Hotel, Corso composed his poem *Bomb* – famously laid out on the page in the shape of a mushroom cloud. Ginsberg wrote part of his poem *Kaddish* during his time there, while Norse composed his experimental novel *Beat Hotel*, using something called the cut-up technique, whereby written text was cut up with scissors and rearranged in order to manufacture a completely new text. But, arguably, the most famous work of all penned here was Buroughs' *Naked Lunch*, his 1959 novel of loosely connected vignettes all about drugs and junkies.

Nowadays, there's a far more salubrious hotel on the same site – the four-star Relais du Vieux Paris. The owners still describe it as "The Beat Hotel", though, and are clearly proud of their literary past. In July 2009 a special ceremony was held outside the hotel, and a plaque was attached on the outside, near the front door. Writ large upon it are the names of the most famous writers who resided in the old flea-pit, back in the day.

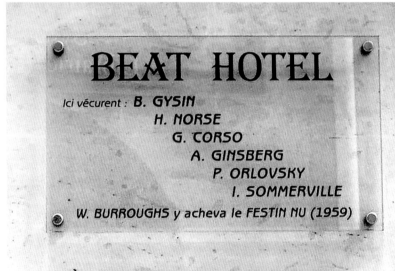

TOP An evening at the 'Beat Hotel' with Madame Rachou behind the bar.

ABOVE The Relais Hôtel du Vieux Paris commemorates its former residents with a plaque outside.

> **"** At night I would climb the steps to the Sacré-Coeur, and I would watch Paris, that futile oasis, scintillating in the wilderness of space. I would weep, because it was so beautiful, and because it was so useless. **"**

Simone de Beauvoir,
Memoirs of a Dutiful Daughter

Simone de Beauvoir and Jean-Paul Sartre

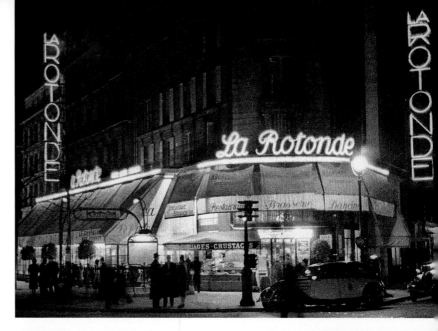

S artre and de Beauvoir. In French literature, indeed in world literature, has there ever been a pair so inextricably linked, and who together achieved such an elevated literary status?

Both born in Paris, just two-and-a-half years apart, Sartre was raised in Meudon, in the southwest suburbs of the city, and later in La Rochelle, on the west coast, while de Beauvoir grew up in an apartment above La Rotonde brasserie on Boulevard du Montparnasse.

They first met while studying in Paris for the 'aggregation', an exam that would lead to a career in the French schooling system. Sartre, a badly dressed student with a wandering right eye, had observed the good-looking de Beauvoir from afar. Keen to be introduced, he sent her a sketch he had done of the philosopher Leibniz, the subject of her thesis.

The gesture worked, and she agreed to join him for a study session in his student digs. It was hardly the most romantic spot for a first date, though. The room was a pigsty, the bed unmade, books and documents scattered everywhere, ashtrays filled to the brim with cigarette ends. But de Beauvoir stayed, and together they discussed philosophy while listening to the music of Jacques Offenbach.

During the 1930s and 1940s, both taught at various secondary schools in Paris and in the provinces, until they had earned enough money to support themselves through

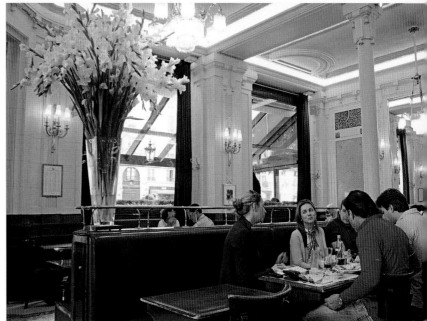

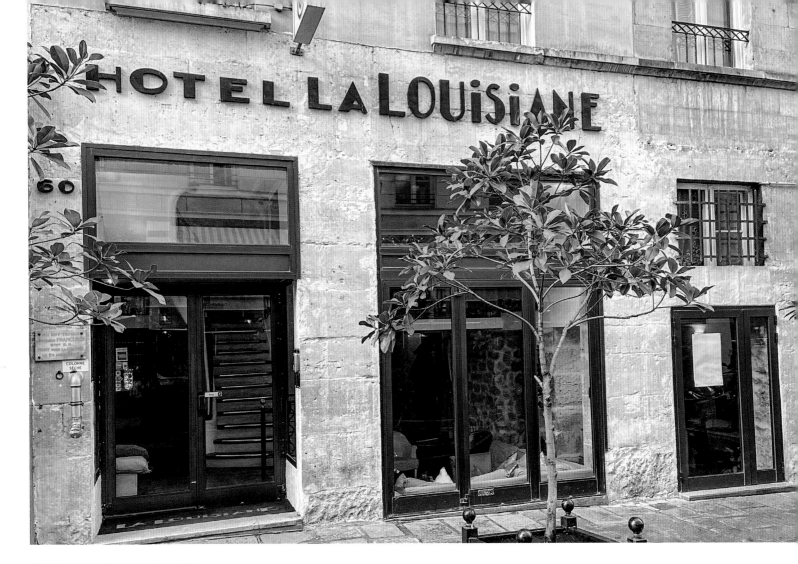

ABOVE Sartre and de Beauvoir moved to the Louisiane in 1943. He left in 1946, she moved out two years later.

ABOVE LEFT De Beauvoir lived her early life in an apartment above La Rotonde.

LEFT The interior of Les Deux Magots – de Beauvoir preferred the corner window seat.

their writing. They then embarked on stellar literary careers, he penning novels and essays such as *La Nausée* (*Nausea*), *Le Mur* (*The Wall*) and *L'Etre et le Néant* (*Being and Nothingness*), she producing works such as *Le Deuxième Sexe* (*The Second Sex*) and *Les Mandarins*.

Sartre initially intended to enter into a romantic relationship with de Beauvoir, and asked her to marry him, but only on a provisional basis. 'Let's sign a two-year lease,' he supposedly said. After she turned him down they agreed instead to engage in a lifelong partnership of the soul. This meant they would sleep together, but were also permitted to pursue other lovers. They rarely lived together. Even when they occupied the same building, they would normally take separate rooms. It was this unorthodox liaison which created interest in their relationship.

Nevertheless, for half a century, their social, sexual and professional lives constantly intertwined, enduring periods of separation – for example during World War II when Sartre was interned by the Germans in a prisoner-of-war camp for a time.

While together in Paris, both before and after the war, they often met up at cafés, brasseries and restaurants such as Les Deux Magots, Café de Flore, and Le Grand Véfour, where they would philosophise, write and edit each other's work. A square near Les Deux Magots was later named Place Jean-Paul-Sartre-et-Simone-de-Beauvoir in their honour.

Together they challenged the bourgeois lifestyle and attitudes they had both been brought up with, considering conformity an inauthentic way of life. Both embraced hugely influential branches of politics and philosophy, Sartre concentrating on existentialism and Marxism, de Beauvoir on existentialism and feminism.

Sartre died in 1980, de Beauvoir six years later. They were both buried in Montparnasse cemetery, alongside each other, beneath a single tombstone. Parallel in death, just as they were in life.

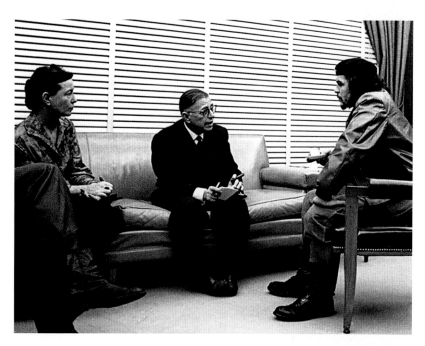

ABOVE Three icons in a room: Sartre and de Beauvoir visited Fidel Castro in Cuba in 1960 during, as Sartre wrote, 'the honeymoon of the revolution'.

RIGHT De Beauvoir photographed in 1952 in her apartment on Rue de la Bûcherie. She moved there after the Louisiane.

OPPOSITE Close to the National Library of France is the Passerelle Simone de Beauvoir. The thirty-seventh bridge in Paris was opened in 2006.

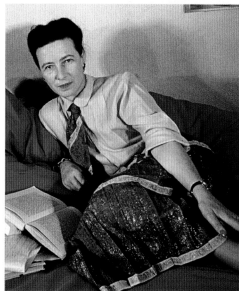

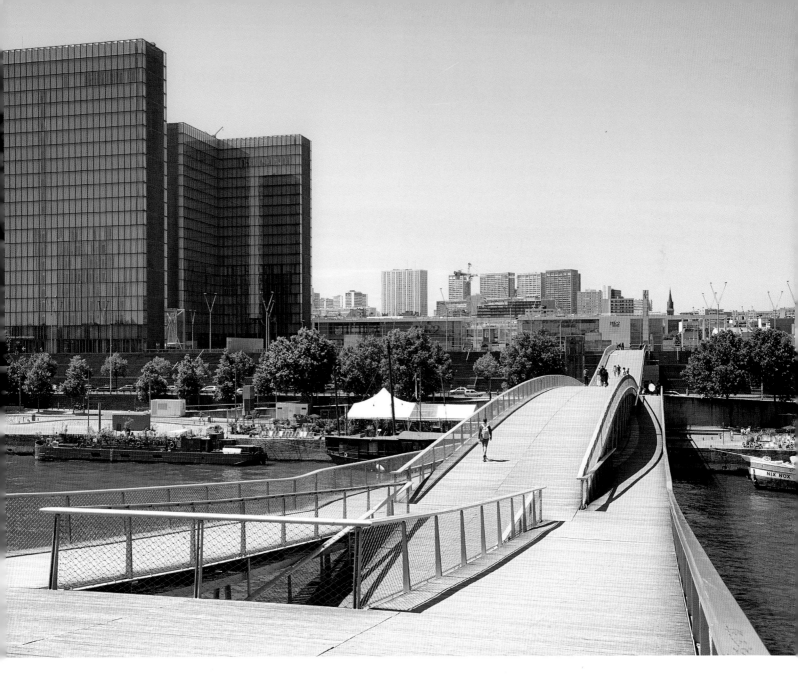

Colette

Considered one of France's greatest female writers, Sidonie-Gabrielle Colette was brought up in the Burgundy countryside but relocated to Paris after marrying the much older author and publisher Henry Gauthier-Villars, or Willy, as he was known. Although she always professed to find the capital city a filthy, banal place, it had a huge influence on her, allowing her bohemian personality and bisexuality to reveal itself. Indeed, her first four novels, the *Claudine* series, were a semi-autobiographical and sexually titillating account of the coming of age of a young provincial girl in Paris. They were written under duress, however, since Willy would often lock his wife away until she had produced a certain quota of work. And when they were finally published, it was under his name, not hers.

Colette lived in at least 14 residences in Paris, including Rue Jacob, Rue de Courcelles, Rue de Villejust, Rue Torricelli and Rue de Beaujolais. She eventually divorced the overbearing Willy, embarking on a series of lesbian affairs, and hanging out at the music halls and seedy bars along the Rue de la Gaîté. Denied the profits of her early novels by her ex-husband, she earned a living through music-hall performances and journalism. During this time she embarked on affairs with the American writer Natalie Clifford Barney and Mathilde de Morny, the cross-dressing daughter of the Duke of Morny. An onstage kiss with the latter at the Moulin Rouge in 1907 caused a near riot among scandalised Parisians. She later married the editor of *Le Matin* newspaper, living in his chalet on Rue Cortambert with a menagerie of cats, dogs, snakes and lizards.

During the German occupation of World War II she lived in the Palais-Royal, in the first arrondissement, with her third husband, and it was here that she spent her final years, crippled by arthritis, confined to her divan, and surrounded by pet cats.

On her death in 1954, she became the first French woman of letters to be granted a state funeral, and was buried in Père Lachaise cemetery. In 1996 a small square in the first arrondissement was named Place Colette in her honour.

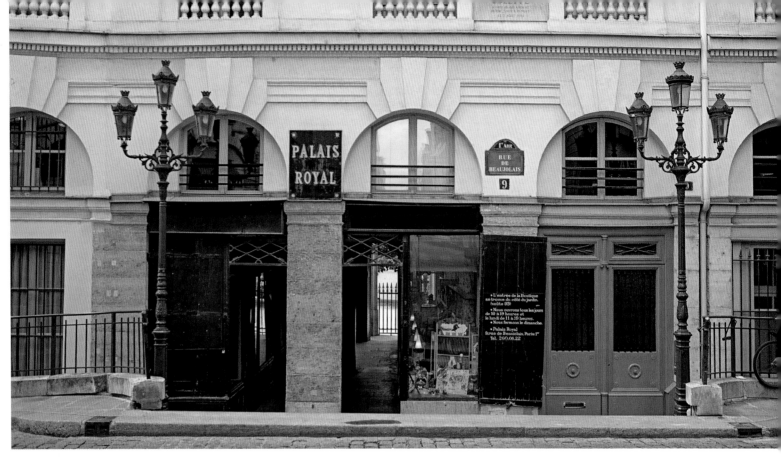

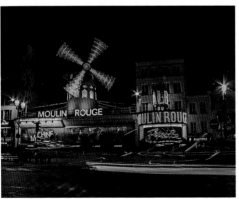

ABOVE Colette's final years were spent in an apartment on Rue de Beaujolais in the Palais-Royal.

LEFT Colette in her 'Reve d'Egypte' costume in which she shared a kiss with 'Missy' de Morny at the Moulin Rouge.

OPPOSITE The six-storey house at 28 Rue Jacob where Colette lived with Willy and where she penned the first *Claudine* novel.

'The whole of Paris was lit up. The tiny dancing flames had bespangled the sea of darkness from end to end of the horizon, and now, like millions of stars, they burned with a steady light in the serene summer night. There was no breath of wind to make them flicker as they hung there in space. They made the unseen city seem as vast as a firmament, reaching out into infinity.'

Émile Zola, *Une page d'amour*

RIGHT An aerial view of Paris with a distant Arc de Triomphe and the dome of Les Invalides cathedral to the right.

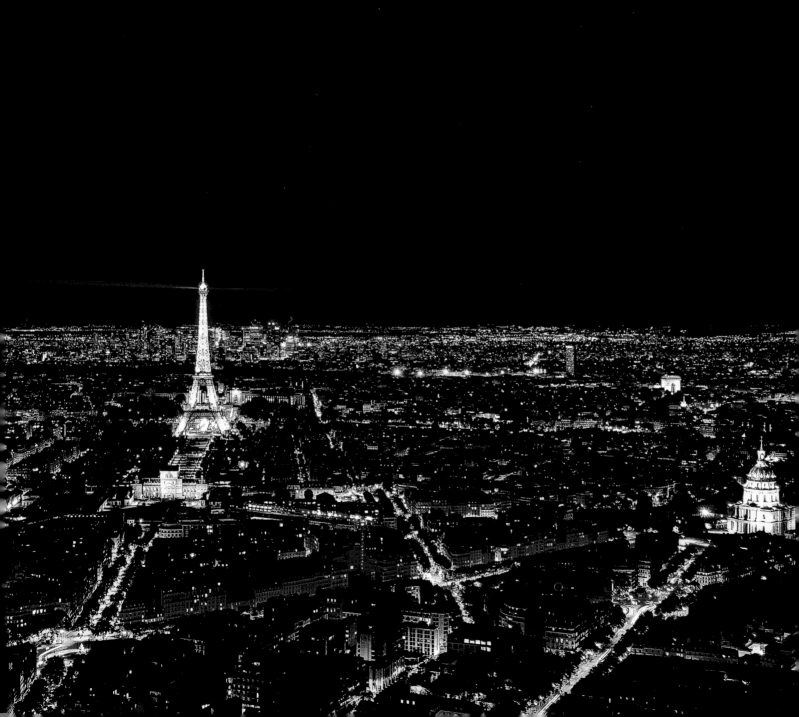

Alexandre Dumas

On first arriving in Paris, in his early twenties, Alexandre Dumas felt very much the outsider. Not only was he a boy from the provinces with little formal education, but he was of mixed race – his aristocratic grandfather had married a slave from Haiti (then Saint-Domingue).

Dumas's early plays quickly brought him success and renown, however, and he became a celebrity at Paris's great theatre, the Comédie-Française. Along with the other Romantic writers, he would meet up at the Arsenal, the huge library in the fourth arrondissement, for literary (and very boozy) dinners. Politics interested him, too, and in 1830, as a staunch republican, he joined the fight against royal troops in the July Revolution which ended the Bourbon monarchy.

By the time he entered his fifth decade, Dumas was a Parisian through and through. With the profits from his writing he bought a home in the western suburb of St-Germain-en-Laye and had the beautiful Château Monte-Cristo constructed nearby. Renaissance in its architectural style, it still has the portraits of Dumas's favourite writers sculpted on its façade. His own sculpted portrait is above the front door, alongside the family's coat of arms and motto, *J'aime qui m'aime* ('I love whoever loves me'). Today, the grand old building is a museum dedicated to the writer and open to the public.

Since Dumas's death in 1870, Paris has been sure to pay tribute to one of its greatest men of letters. In the Place du Général-Catroux, in the 17th arrondissement, there is an imposing statue. (Nowadays he is often referred to as Alexandre Dumas *père*, in order to distinguish him from his son Alexandre Dumas *fils*, whose statue also appears in the same square.) In 1970, on the centenary of his death, the Paris Métro station Alexandre Dumas was named in his honour. Finally, in 2001, his remains were disinterred from his home town in Villers-Cotterêts, north of Paris, and moved to the Panthéon, where he was buried alongside his literary peers Victor Hugo and Émile Zola.

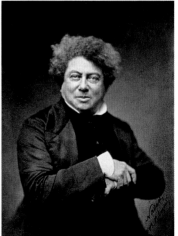

ABOVE A bust of Dumas adorns a building at the junction of Rue Alexandre Dumas with Boulevard Voltaire.

RIGHT Dumas photographed around 1855. The author encouraged Jules Verne in his early career.

OPPOSITE Located near the Seine, on the western outskirts of Paris, the Château de Monte-Cristo is now a museum.

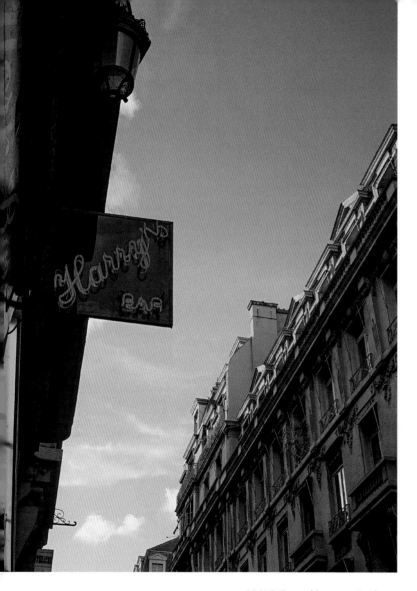

ABOVE Fitzgerald was most at home in American-themed bars such as Harry's. In *A Moveable Feast* Hemingway describes Fitzgerald's strange antipathy towards the French.

F. Scott Fitzgerald

It was while working on his book *The Great Gatsby*, in May 1924, that F. Scott Fitzgerald first relocated from the United States to Europe with his wife Zelda and daughter Scottie. Splitting his time mainly between the French Riviera and Paris, he settled in with a group of American expatriate writers based in the capital, later known as the Lost Generation. One of his best friends and confidants was Ernest Hemingway, but almost all of his Paris friends were English speaking, as unlike 'Hem' he failed to learn French.

Fitzgerald's relationship with his wife was nowhere near as amicable, however. The writer didn't know it at the time, but Zelda was starting to lose her mind. There were often fireworks between man and wife, exacerbated by her mental state and his excessive drinking. At times their marriage was toxic, marred by jealousy, infidelity and bitter arguments. Zelda did her best to belittle her husband and begrudged the time he spent working, or going out with Hemingway.

Between 1924 and 1931, Fitzgerald, his wife and their daughter stayed in Paris five times. At one point they rented an apartment overlooking the Luxembourg Garden, where the writer started working on his novel about the French Riviera during the Jazz Age, *Tender Is the Night*. Later they lived on Rue de Tilsitt, close to the Arc de Triomphe.

But home life held little interest for Zelda, who was intent on starting a career as a ballet dancer in her twenties. More often they were to be found in one of the city's many bars and clubs – Le Grand Duc and Bricktop's, in Lower Montmartre, and the Ritz Hotel were particular favourites – Fitzgerald always drinking to excess, his wife showing increasing signs of mental instability.

Bricktop's was the nightclub that Fitzgerald described in great depth in his 1931 story *Babylon Revisited*. Owned by the red-haired

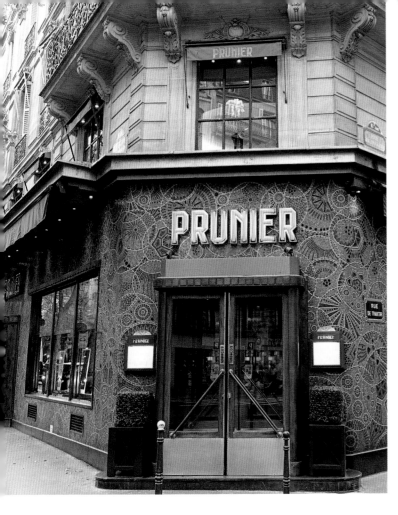

Black American performer of the same name, it included Cole Porter and the Duke and Duchess of Windsor among its regulars. Bricktop was good friends with Fitzgerald and tolerated his drunken excesses with extraordinary patience. Once she had to placate an irate taxi driver whose windows the writer has smashed while in a drunken stupor.

After returning to America, the Fitzgeralds continued to struggle with their relationship. Scott died suddenly of heart disease in 1940, aged just 44. Zelda lived in and out of mental health institutes, eventually perishing in a fire in one of them, in 1948.

ABOVE LEFT As a successful writer in Paris, Fitzgerald could enjoy the best restaurants, including Prunier, one of the finest, renowned for its seafood.

ABOVE Fitzgerald's apartment at 58 Rue de Vaugirard near the Luxembourg Garden. The family stayed here on their third trip to Paris in 1928.

Ernest Hemingway

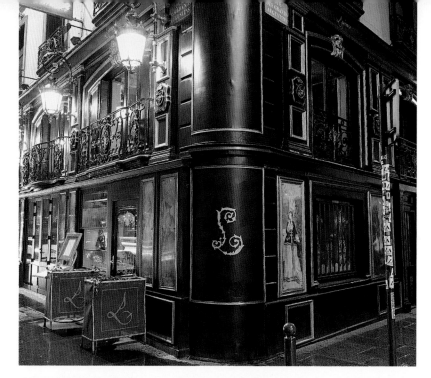

They called them the Lost Generation. It was the novelist Gertrude Stein who first applied this borrowed phrase to the group of her American compatriots living in Paris during the 1920s. They were the generation decimated by the losses of World War I. Ernest Hemingway cemented its place in literary culture thanks to the last line of his 1926 novel *The Sun Also Rises*. 'You are all a lost generation,' he wrote.

Hemingway himself, who spent most of the 1920s in the French capital and produced much of his greatest work while living there, may have been more lost than most – often broke, cold in winter, living in cheap accommodation, his first marriage on the rocks. But it was in Paris that he found his literary voice. Here he met and was influenced by Stein, by the American poet Ezra Pound, and by the Irish novelist James Joyce. Here he wrote some of his most important journalism, travelling east to report on the Greco-Turkish War. But most importantly, it was in Paris that he worked on some of his most famous novels and short stories, including *Men Without Women*, *In Our Time*, and *A Farewell to Arms*.

Throughout the 1920s, Hemingway lived all over the capital. On first moving there with his wife Hadley, he stayed at the Hôtel d'Angleterre, in the sixth arrondissement, returning to it many times. Modern-day visitors can book his favourite room if they wish – number 14.

Hemingway and Hadley then occupied a cheap apartment on Rue du Cardinal Lemoine, in the fifth arrondissement with a shared lavatory at the end of the corridor. The accommodation was so basic that the writer was forced to

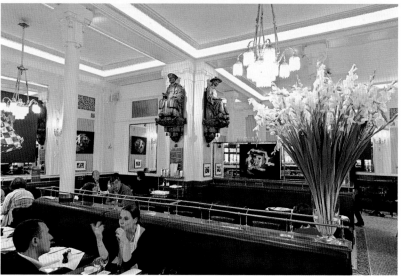

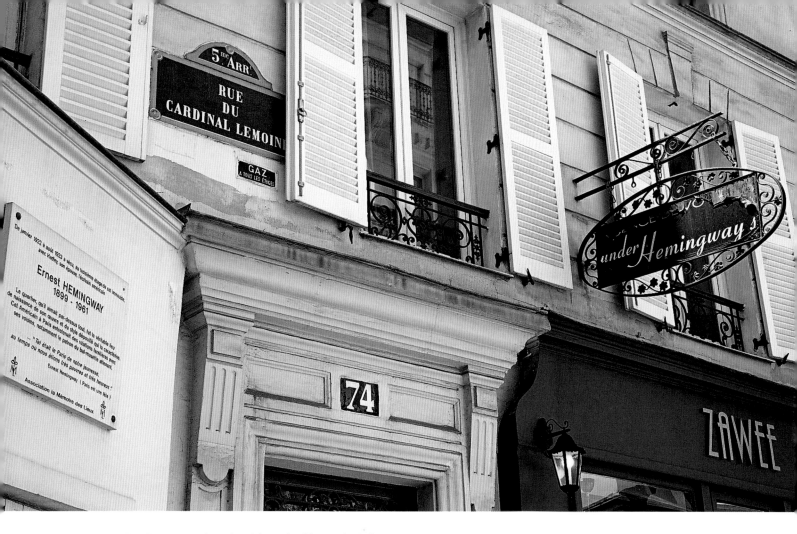

rent a tiny garret on Rue Descartes where he did much of his work. Today, a white plaque marks the front door of the Rue du Cardinal Lemoine apartment building.

In the late 1920s, after he had divorced Hadley and married Pauline Pfeiffer, Hemingway lived in the Hôtel de Luzy on Rue Férou – a sumptuous accommodation compared to his earlier haunts. It was here, buoyed by the luxury of having a salon, a dining room, a large kitchen and a study, that he wrote *A Farewell to Arms*.

OPPOSITE TOP It was only after literary success that Hemingway could afford Lapérouse (est. 1766) and join the likes of Zola, Maupassant, Baudelaire, Proust, Hugo and Colette.

OPPOSITE BOTTOM Les Deux Magots with the two antique figurines on high.

ABOVE The apartment at 74 Rue du Cardinal Lemoine.

ABOVE Hemingway claimed to have liberated the Ritz Hotel in Place Vendôme after the Allied push into Paris in 1944. Today there is a bar named for him.

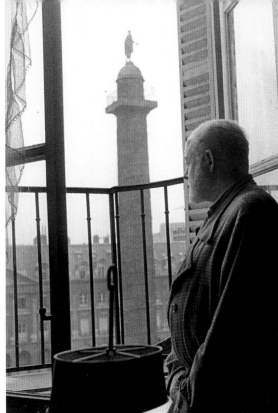

But it was the cafés and restaurants of Paris where he got his early writing done. Inspired by an exciting coterie of writers and artists, he used to work (and drink, often to excess) at Les Deux Magots, Café de Flore and Brasserie Lipp, in Saint-Germain-des-Prés, at La Closerie des Lilas, in Montparnasse, and at Harry's New York Bar, on the Right Bank. In *A Moveable Feast* he describes in detail the irritation he felt at being interrupted while at work at 'the Lilas', his office.

One of his favourite parks was the Jardin du Luxembourg, in the sixth arrondissement. Here, during his early days in Paris, impoverished and hungry, he would sneak up on unwary pigeons, wring their necks, hide the bodies in his son Bumby's pram, and smuggle them home for dinner. At other times he would stroll along the Seine, browsing books at the many bouquiniste bookstalls lining the river.

Hemingway described in detail his time living in Paris in his memoir *A Moveable Feast*, published posthumously in 1964. The almost-finished account – his literary executors gave it the title – was based on notebooks the author found in two steamer trunks deposited at the Ritz Hotel in 1930. While lunching there in 1956, hotel chairman Charles Ritz asked him if he knew he had left them in storage and would he like them back…?

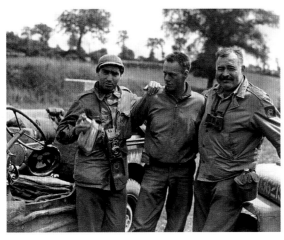

Victor Hugo

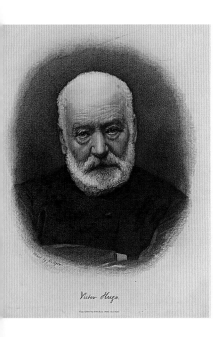

Born in Besançon, near the Jura Mountains, Victor Hugo spent much of his early life dragged between military postings because his father was an officer in Napoleon's army. At the age of 13, Victor and his brother Eugène were sent to school in Paris, at the Pension Cordier and the Lycée Louis-le-Grand. Two years later, young Victor had already been recognised for his writing, after receiving an honourable mention in a poetry competition organised by the Académie Française. They refused to believe he was only a mere 15 years of age.

The young Hugo was obsessed by the royalist writer François-René de Chateaubriand, and resolved to follow in his footsteps. By 1830, after the performance of his plays *Cromwell* and *Hernani*, he became the spearhead of the Romantic literary movement, inviting fellow Romantics to his home on Rue Notre-Dame-des-Champs. After *Hernani* was performed at the Comédie-Française, there were several nights of rioting as Romantics argued with Classicists, who considered the play an attack on their values.

Hugo's 1831 novel *Notre-Dame de Paris* (in English, *The Hunchback of Notre-Dame*) was an enormous influence on his adopted city. In it, the eponymous cathedral becomes a fully-fledged character all of its own. Sorely neglected while Hugo had been writing his book, and at risk of being pulled down, the building – much-loved by the writer – enjoyed a second life after publication of the novel, and benefited enormously when a campaign to save it was launched. The young architect Eugène Emmanuel Viollet-le-Duc was so moved by Hugo's novel that he embarked on a major restoration.

It was around this time that the writer moved with his wife Adèle and four children to an apartment at the Hôtel de Rohan-Guémené

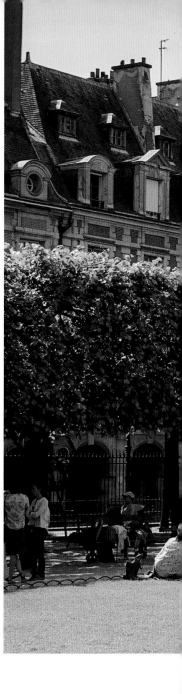

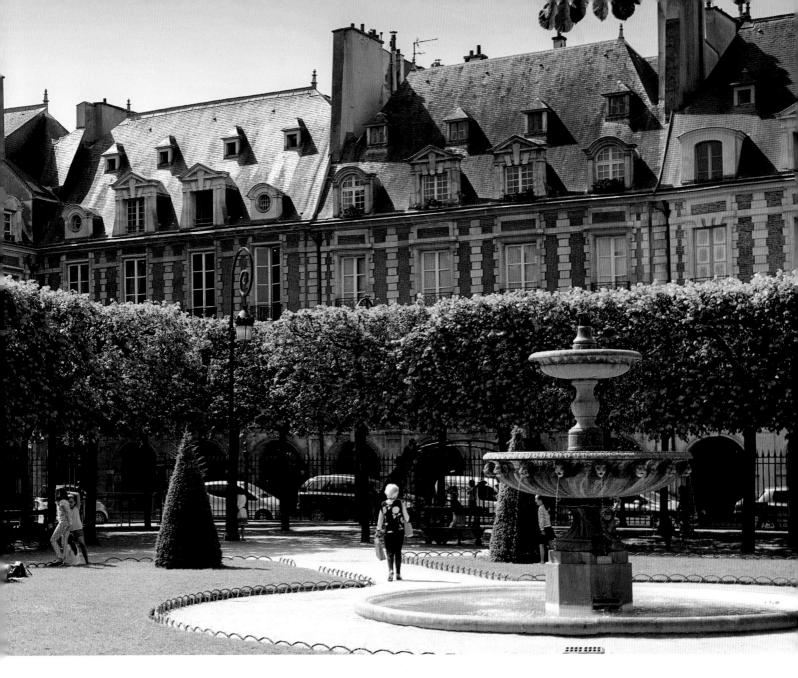

ABOVE AND OPPOSITE BOTTOM
Two images from the Maison de Victor Hugo museum located in the Place des Vosges. It is one of the 14 City of Paris museums.

OPPOSITE TOP Hugo's novel *Notre Dame de Paris* helped focus Parisians' love of the building and ultimately made its replacement unthinkable.

on Place des Vosges. Nowadays the building is the Musée Victor Hugo, which celebrates his life in Paris and his work as a writer.

By the mid 1840s, Hugo had entered politics. However, after a major disagreement with Napoleon III, he was forced to exile himself with his family to Guernsey, from where he continued to campaign vociferously against slavery (which Napoleon Bonaparte had reintroduced in 1802 and was only ended in 1848) and the death penalty, among other social injustices.

It was while in Guernsey that Hugo penned his most famous novel of all, *Les Misérables*. Published in 1862, it follows the fortunes of Jean Valjean, an escaped convict determined to redeem himself of his criminal past. The book's depictions of a pre-Haussmann Paris, with its poverty, its dank sewers and congested alleyways, its dynamic inhabitants, all set against the backdrop of revolution, have imprinted themselves on generations of readers' minds.

In the early 1870s, after the death of Napoleon III, the Hugo family finally returned to Paris, and settled in Rue de Clichy. They were present in the city during the Siege of Paris – forced to eat exotic animals from the city zoo – when the Paris Commune took power in 1871.

As old age and ill health set in, Hugo was advised by doctors to move to a new home without stairs. Avenue d'Eylau, in the 16th arrondissement was his choice. It was here, after he reached the age of 80, that some 600,000 admirers paraded past his front door while the ailing writer gazed proudly out of the window. The city of Paris then changed the name of his street to Avenue Victor Hugo.

On 1 June 1885, ten days after his death from pneumonia at the age of 83, more than two million of his compatriots followed Hugo's funeral cortege from the Arc de Triomphe to the Panthéon, where he was finally laid to rest. Alexandre Dumas and Émile Zola now share his crypt.

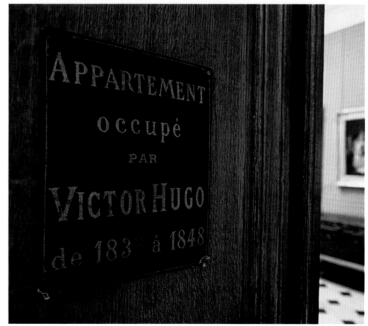

James Joyce

James Joyce arrived in Paris in July 1920 and soon found his way to Sylvia Beach's bookshop, Shakespeare and Co. The Irish writer had lived most of his adult life as an expatriate, with spells in Trieste and Zurich, but his expensive tastes necessitated a move to somewhere more affordable. When he arrived in Paris he was already a published novelist with *Dubliners* (1914) and *A Portrait of the Artist as a Young Man* (1916), but book royalties could not cover all his expenses and he was supported financially by Beach (who also lent money to Ernest Hemingway) and by English feminist Harriet Shaw Weaver, who had published his work before in *The Egoist* magazine. Joyce finished his masterwork *Ulysses* in Paris, and Beach made it her mission to get it published. One of the groundbreaking novels in the English language was first published on 2 February (Joyce's birthday) 1922, but it was banned for indecency in Britain, Ireland and the United States.

Joyce with his failing eyesight and thick glasses, along with wife Nora, son Giorgio and daughter Lucia, was easily spotted in the upmarket restaurants such as Michaud's and Fouquet's. He typically chose accommodation on the Right Bank, not the cheaper bohemian Left, and changed apartments so frequently that a whole book, *The Paris Residences of James Joyce*, was written detailing his 18 addresses, all verified by his frequent correspondence with friends in Dublin.

In the mid 1930s he moved to 7 Rue Edmond-Valentin, close to the Eiffel Tower, and the family were living there when Samuel Beckett – who, as an admirer helped Joyce with the drafting of *Finnegans Wake* and often read to him – was stabbed in a random street attack. Joyce and Beckett later fell out over the younger man's supposed treatment of Lucia Joyce, but communication resumed when Joyce realised that it was a product of his daughter's imagination.

Relations with Sylvia Beach cooled after Joyce sold the American rights to *Ulysses* to Random House (it was finally published in the US in 1934), cutting his first English-language publisher out of the deal entirely. While

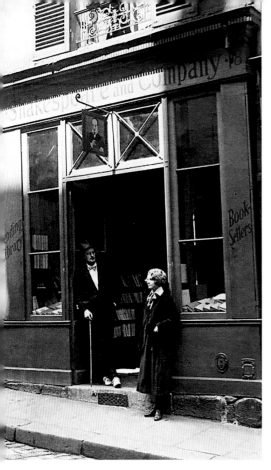

ABOVE James Joyce with Sylvia Beach in the doorway of the original Shakespeare and Co. shop at 8 Rue Dupuytren around 1920. Gertrude Stein was furious when Beach chose to publish Joyce's novel over her own.

ABOVE RIGHT Many restaurants with literary connections have aggrandised over the years, but Fouquet's at 99 Avenue des Champs-Élysées has always been a high-end brasserie.

OPPOSITE Rue Edmond-Valentin in the shadow of the Eiffel Tower.

Joyce enjoyed fine tailoring, the Shakespeare and Co. bookshop went into decline, yet Beach remained an enduring supporter of his work.

Joyce had just moved to Rue des Vignes near the Balzac Museum when *Finnegans Wake* was finally published in May 1939, but their Paris stay was ended by the German invasion of June 1940, and Joyce returned to Switzerland for what would prove to be the last few months of his life.

The Luxembourg Garden

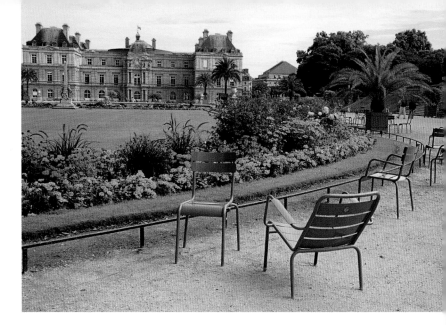

The Luxembourg Garden has provided a backdrop for many great novels over the years. It was Marie de' Medici who first commissioned a palace here along with a formal garden in the style of those she had known as a child in Florence. Tommaso Francini planned the two terraces with balustrades and parterres laid out either side of a Grand Bassin, used to sail model boats. Medici also commissioned a fountain, which was completed in 1631 and still flows today.

The Three Musketeers, Athos, Porthos and Aramis, would play tennis with d'Artagnan in a *jeu de paume* court in the Luxembourg. Honoré de Balzac, a notorious insomniac, is said to have strolled through the garden at night holding a candelabra and dressed in the monk's cowl he would often wear to write.

It was in the Luxembourg Garden that the central character of Henry James' great novel *The Ambassadors* has the epiphany that will change his life, but perhaps the best-known use of the garden is by Victor Hugo. In *Les Misérables* it is here that Marius first catches a glimpse of Cosette.

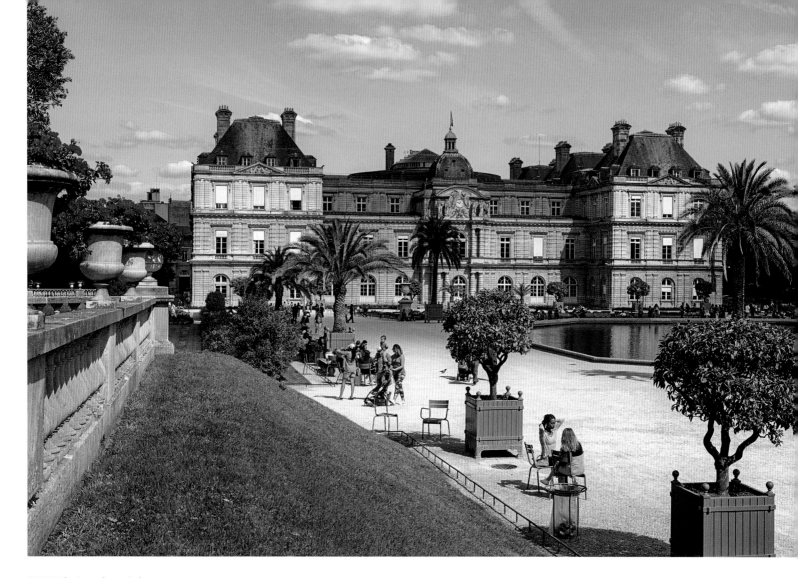

ABOVE The Luxembourg Palace was originally built to be the royal residence of Marie de' Medici, mother of King Louis XIII, but after the Revolution it was re-fashioned into a legislative building.

LEFT Wooden sailboats can still be rented to sail on the octagonal Grand Bassin.

"

One day the air was mild, the Luxembourg was flooded with sunshine and shadow, the sky was as clear as if the angels had washed it in the morning, the sparrows were twittering in the depths of the chestnut trees, Marius had opened his whole soul to nature, he was thinking of nothing, he was living and breathing, he passed near this seat, the young girl raised her eyes, their glances met.

Victor Hugo, *Les Misérables*

"

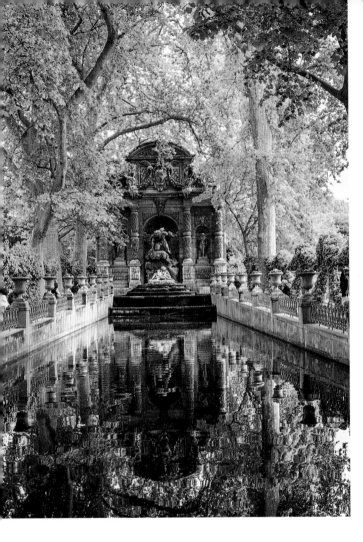

ABOVE The Medici Fountain of 1631 still graces the garden, but it was moved to its current position in 1866.

ABOVE RIGHT The Luxembourg Garden was enjoyed by both writers and their children. John 'Bumby' Hemingway was taken here, as was Scottie Fitzgerald.

André Gide was born in a house overlooking the garden, and his 1926 novel *The Counterfeiters* is set in the garden and its surrounding streets. Ernest Hemingway, on his regular visits to Gertrude Stein at 27 Rue de Fleurus, would pass though the garden. In the memoir of his Paris years, *A Moveable Feast*, he described it as the perfect destination when broke and hungry, away from the tempting smells of restaurants and patisseries: 'The best place to go was the Luxembourg gardens where you saw and smelled nothing to eat all the way from the Place de l'Observatoire to the Rue de Vaugirard.'

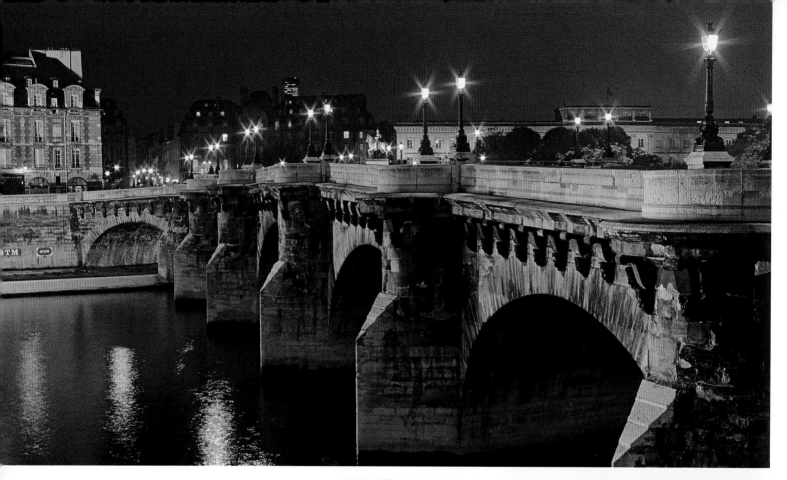

ABOVE Molière's success was a long time coming. In his early days he would perform in converted *jeu de paume* courts or in the parapet bays of the Pont Neuf.

RIGHT Real tennis, or *jeu de paume*, courts were perfectly adaptable for putting on plays. This is a former court from the palace at Versailles.

OPPOSITE A statue of Molière by Seurre sits on top of La Fontaine Molière at the junction of Rue Molière and Rue de Richelieu. It was France's first public subscription monument to a civilian figure.

Molière

The French often refer to their own language as the language of Molière. That's how much influence this great playwright still wields on the culture of his nation. If there's a French equivalent of Shakespeare, Molière is surely it. Jean-Baptiste Poquelin (his real name) was born in Paris in 1622. As a young man he lived above the Pavillon des Singes, on Rue Saint-Honoré, and was educated at the Jesuit Collège de Clermont. His father, a royal valet and upholsterer, wished him to take on that profession, or to study law, but Molière had set his heart on acting.

His first theatre company, set up with the actress Madeleine Béjart, was called the Illustre Théâtre. Its home was a real tennis court, the Jeu de Paume des Mestayers, on the Rue Mazarine. Within two years it had gone out of business. It was around this time that Molière adopted his stage name, possibly to spare his father the embarrassment of having a thespian in the family.

For the next dozen years Molière and his troupe scratched out a living in the provinces. His big break came in 1658 when he performed a comedy sketch for King Louis XIV at the Louvre. The latter was so impressed that he awarded the company a regular theatrical slot at the Hôtel du Petit-Bourbon, part of the Louvre palace.

From then on, Molière's career flourished, thanks to performances at the Théâtre du Palais-Royal and the penning of over thirty major plays. Some, such as *Tartuffe* – with its depiction of upper-class hypocrisy – incurred the wrath of those it satirised. Many of his farces and satires, though, endeared him to the theatre-going public. Prudently, he never took aim at royalty, ensuring consistent patronage from the King.

In 1673, Molière collapsed on stage in a fit of coughing, ironically while performing in *Le Malade Imaginaire* (*The Hypochondriac*). Taken from the stage in a chair used on set, he died soon afterwards at his house on Rue de Richelieu. At the time, actors were not allowed to be buried in sacred ground. However, after intervention from the King, his body was laid to rest in Saint-Joseph Church. In 1817 his remains were transferred to the Père Lachaise cemetery.

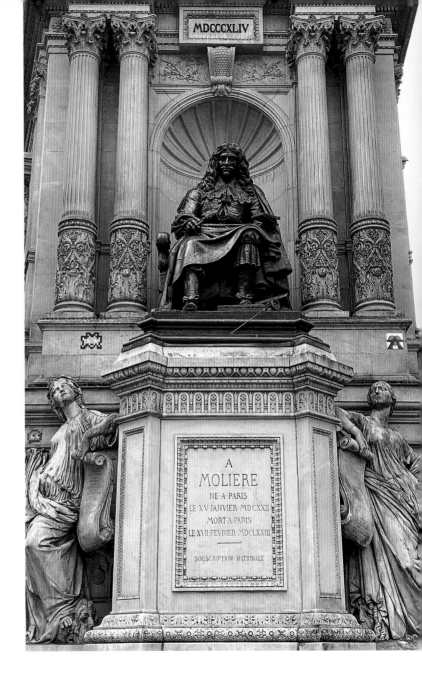

George Orwell

George Orwell firmly established his writing career with *Down and Out in Paris and London*. Up until its publication in January 1933, English magazines and newspapers had printed a few of his socially aware articles, but it was the *Times Literary Supplement*'s comparison of Orwell's eccentric characters to those of Dickens, which helped it become a modest success. Harper Brothers in New York picked up the book as well.

Unlike the American writers who came to Paris to be inspired and become part of the literary scene, Orwell was a loner who deliberately chose a life of poverty to garner material for his work. He had originally come to Paris to write pieces for *Le Monde* and a book about his years in Burma as an Imperial policeman, but that was soon set aside. Having already tramped around London, his curiosity about the lives of the Parisian working class took over. His aunt Nellie Limouzin, who would help him throughout his career, lived in Paris and could have been called upon at any time. Instead Orwell chose to endure the privations of living off two francs a day, at one stage pawning his decent clothes and overcoat to buy food.

He lived in the Hôtel des Trois Moineaux at 6 Rue du Pot de Fer (off the famous Rue Mouffetard), which he renamed in the book as 'Rue du Coq d'Or' and described in detail the squalid conditions of bugs in his room, and the concierge shouting from the street at a resident who was crushing them against the wallpaper.

After his money was stolen – in the book by an Italian typesetter, but most likely by a prostitute – he was forced to work as a *plongeur*, a washer-up in a high-class Paris hotel where there was a caste system of workers and he was at the very bottom. In reality it was the Hôtel Lotti on the Rue de Rivoli, and Orwell painted a vivid picture of life in the gilded restaurant and the grim conditions in the kitchens, just the other side of a swing door. It was a vision of Paris not promoted by the Lost Generation.

Living this life allowed him to scorn his fellow expatriates: 'Paris was invaded by such a swarm of artists, writers, students, dilettanti, sightseers, debauchers and plain idlers as the world has probably never seen. In some quarters of the town the so-called artists must actually have outnumbered the working population.'

ABOVE *Down and Out* gave a vivid depiction of the chaos and state of the kitchens in the Hotel Lotti.

RIGHT Orwell described the Rue du Pot du Fer as: 'a ravine of tall leprous houses lurching towards one another in queer attitudes, as though they had been frozen in the act of collapse. All the houses were hotels and packed to the tiles with lodgers, mostly poles, Arabs and Italians.'

OPPOSITE The Place Contrescarpe and below it, the Rue Mouffetard were both places frequented by Orwell and Hemingway and today bear little semblance of the seedy, downbeat areas they were in the 1920s.

Marcel Proust

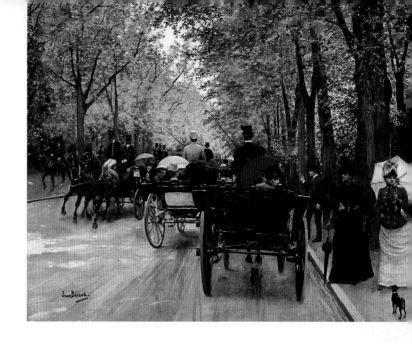

Marcel Proust's most famous work, *A la Recherche du Temps Perdu* (*In Search of Lost Time*) stretches to well over 1.2 million words. Arguably the most famous passage of all is what's known as the madeleine episode early in the first volume, when the author describes rhapsodically the 'exquisite pleasure' and memories of childhood he feels on eating madeleine cakes with tea. The passage, which has confounded many a student of French literature, is based on a real-life experience that Proust had with madeleines in his Parisian home, on Boulevard Haussmann, in the winter of 1909.

Proust was born in 1871, on the western edge of Paris, and grew up on Boulevard Malesherbes, near Parc Monceau, and later went to high school at the prestigious Lycée Condorcet, in the ninth arrondissement.

A shameless social climber, he spent much of his life courting the haute-bourgeoisie and aristocracy, with a jealous eye on the nobler families that lived in Faubourg St Germain, just out of his reach in the nearby seventh and eighth arrondissements. The fact he was half-Jewish and homosexual meant he struggled to be accepted by them. Nevertheless, wealthy school friends and the symbolist poet Comte de Montesquiou-Fézensac introduced him to members of society's elite.

Proust later frequented many a Paris literary salon, brushing shoulders with writers such as Anatole France and André Gide. The latter initially warned publishers off Proust's manuscript for *A la Recherche du Temps Perdu* before realising his mistake.

Among Proust's favourite Parisian hang-outs were the Bois de Boulogne (the vast park on the city's western edge), the Jardin des Plantes (the botanical gardens in the fifth arrondissement), and Comte de Montesquiou-Fézensac's family home on Quai d'Orsay, where Proust's aristocratic friend inhabited the attic, or the *Cave d'Ali Baba*, as he called it.

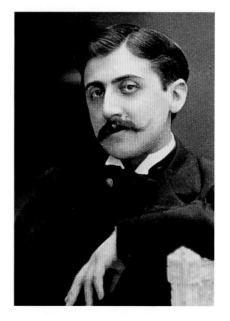

ABOVE Proust admired Parisian high society and the carriage rides he observed them taking to the Bois de Boulogne.

RIGHT Proust in his late twenties.

OPPOSITE His parents helped him get an unpaid – but prestigious – post at the Bibliothèque Mazarine at 23 Quai de Conti, which required his attendance two days a week.

Georges Simenon

Georges Simenon was both a prolific author and an adroit self-publicist. By the age of twenty-one he could already afford to move into a townhouse in the corner of Place des Vosges – Victor Hugo's home turf – with his wife Tigy. Number 21 had once been occupied by the Duke de Richelieu until the Marais became less fashionable. Simenon was guided in his early career by Colette, who had become the literary editor of *Le Matin* and in 1923 critiqued his short stories. Simenon took her advice not to try and write 'literature' and never looked back. He was reputed to turn out 80 pages of fiction a day in his prime and once proposed to write a novel entirely enclosed in a glass case – though he never did. He was twenty-eight and yet to create Inspector Maigret when he embarked on a year-long affair with dancer Josephine Baker in 1926. Baker was the toast of Paris, star of *La Revue Nègre* and who would go on to astound audiences with her banana-skirt dance at the Folies Bergère.

It was not until 1931 that the first Maigret story appeared, followed by 109 novels, 77 of them set in Paris, with his final case published in 1972. Just as Conan-Doyle had made 221B Baker Street famous, so the Police Judiciare headquarters at 36 Quai des Orfèvres was at the heart of Maigret's world. Today there is a plaque that celebrates Simenon's unflappable pipe-smoking creation on the corner.

Maigret might often have been found in Ma Bourgogne café at 19 Place des Vosges, but the detective spent a lot of his time investigating the seedier parts of Paris, populated by petty criminals, gangsters and prostitutes. Simenon's self-confessed insatiable appetite for sex made him seek out these areas, so he could easily describe them... rather more accurately than the procedures of the Police Judiciare, which he never studied.

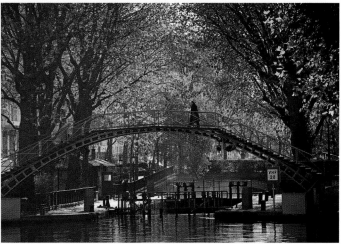

TOP The Quai des Orfèvres, workplace of Inspector Maigret.

ABOVE An autumnal scene on the Canal St. Martin, a regular haunt of both Simenon and Maigret.

RIGHT Looking towards 21 Place des Vosges in the corner of the square.

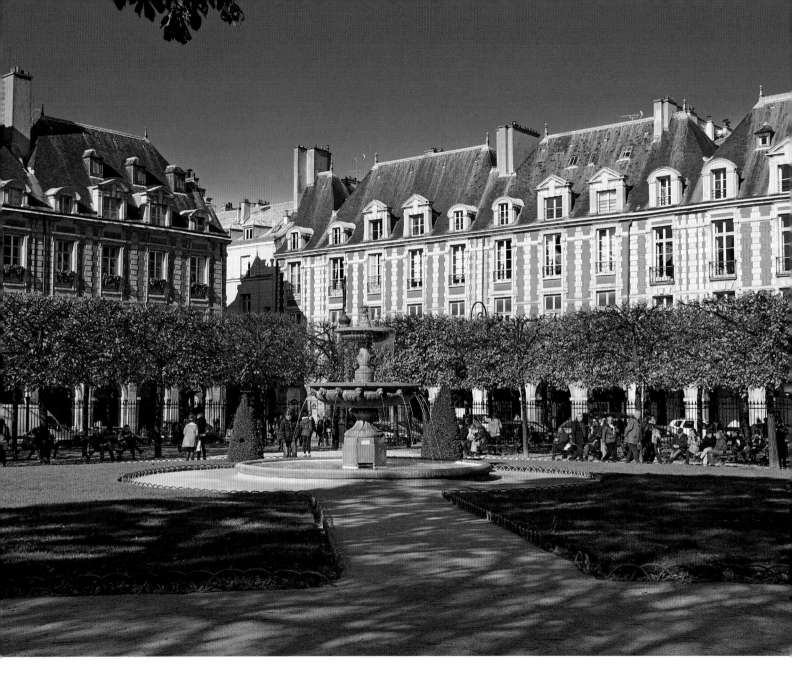

ABOVE The house of Verlaine's parents-in-law at 14 Rue Nicolet, Montmartre.

RIGHT AND OPPOSITE TOP The place where Verlaine died in 1896 was also the location in which Hemingway rented a small room to write.

OPPOSITE Arthur Rimbaud wrote *The Drunken Boat* in 1871. It is the tale of a boat set adrift and in 2012 was printed in full on an ancient wall in the Rue Ferou.

Dans cette maison est mort
le 8 janvier 1896 le poète
Paul VERLAINE
né à Metz le 30 mars 1844
Hommage des amis de VERLAINE
29 juin 1919

Verlaine and Rimbaud

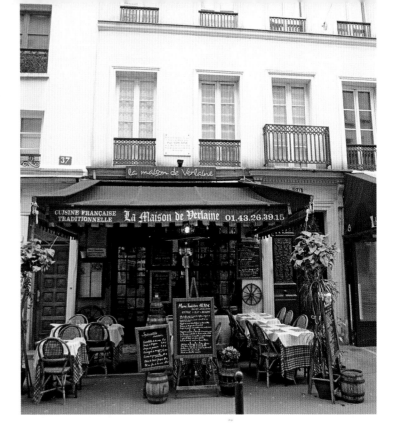

Paul Verlaine was an established poet, part of the *vilains bonshommes* (nasty fellows) circle of poets who were the bright focus of Paris's literary scene in 1871. He had just lost his job at the Hôtel de Ville and he and wife Mathilde had been forced to move in with her parents in Montmartre when they received astonishing verses in the mail from Arthur Rimbaud. Verlaine had no idea that the author was a provincial lad of just seventeen, and the poetry so impressed Verlaine's mother-in-law that she encouraged Verlaine to invite Rimbaud to stay. The dishevelled, raggedy specimen that arrived at 14 Rue Nicolet with a thick regional accent, from Charleville, was not what they expected, but Verlaine soon became obsessed with the teenager, the inspired author of *Le Bateau ivre* (*The Drunken Boat*). Rimbaud despised the bourgeois attitudes of his hosts and broke furniture, borrowed money and rarely washed, until he was thrown out of the house and passed on to the care of other *vilains* poets, where he repeated his antisocial behaviour.

After attempts by Verlaine's inlaws to keep the duo apart failed, they left for Belgium together in July 1872, a liaison that was finally ended when Verlaine produced a revolver after an argument and shot the now nineteen-year-old Rimbaud in the wrist.

Rimbaud left Europe to travel and would write no more poetry, but Verlaine continued his work (in prison and in exile from Paris) and included Rimbaud's poetry in his book *Les Poètes maudits* (1884).

On his return to Paris in 1882, Verlaine was at first shunned by old friends, but gradually re-established a reputation for poetry with new work published in a weekly review from nightclub Le Chat Noir. Despite an ongoing addiction to absinthe he was voted 'Prince of Poets' by the review *La Plume* in 1894 and spent his last few years drinking in Le Procope or various cafés where tourists would stand him drinks.

Voltaire

There's a Boulevard Voltaire, a Rue Voltaire, a Quai Voltaire, an Impasse Voltaire, a Lycée Voltaire, more than a few Voltaire hotels, a Voltaire Métro station and, until recently, a Voltaire statue. (More of that later.) And that's just in Paris. Virtually every city in France has schools, hotels and streets named after this Enlightenment writer, historian and philosopher – evidence of his prolific cultural impact on the entire nation.

François-Marie Arouet, to use his real name, was a Parisian through and through. Born in the capital in 1694, the youngest of five children, he was educated by Jesuits at the Collège Louis-le-Grand. Always a keen writer and an acerbic critic of the corruption of government and the posturing of religion, he soon found himself in trouble with the authorities. He was imprisoned twice in the Bastille and then exiled to England.

Voltaire had many favourite haunts across the capital, playing chess at the Café de la Regence on Rue St-Honoré, for example, or drinking coffee with artists and other playwrights at Le Procope in the Latin Quarter, and staying at the Hôtel Lambert in the fourth arrondissement. But for political reasons, much of his life was spent away from Paris – in England, Dieppe, Cirey-sur-Blaise, Prussia and Geneva.

In February 1778 he made his prodigal return to the French capital, greeted with gusto by fellow Parisians. By the end of May, though, he was dead. Vehemently anti-religious to the end, he was denied a Christian burial, his family forced to bury him secretly in Champagne. But 13 years later, during the Revolution, his remains were returned to Paris where a million or so people attended the procession to the Panthéon where he was finally laid to rest.

In 1878 a bronze statue of Voltaire was commissioned on the 100th anniversary of his death, and placed on Quai Malaquais. Unfortunately, it was melted down during World War II by the occupying Nazis, who considered his liberal ideas politically unsavoury. A new statue was erected in Place Honoré Champion,

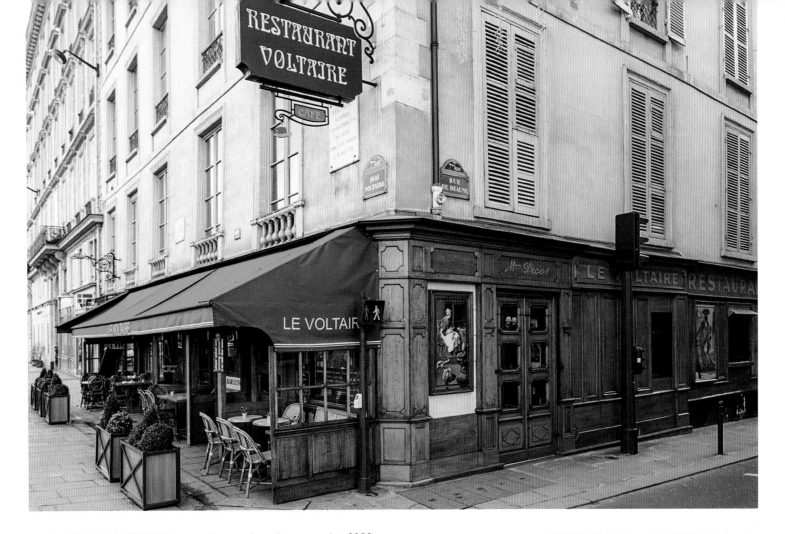

on the Left Bank, in 1962. This second statue then disappeared in 2020, thought to be a victim of cancel culture, since many on the political left consider Voltaire a symbol of racism and colonialism. It turns out it was the city authorities who removed the statue, however, in order to clean it of paint daubed by vandals and to restore it after years exposed to the elements. It will soon find a new home at the university medical school. 'The City of Light will continue to have its man of Enlightenment,' said the deputy mayor of Paris, Karen Taïeb.

OPPOSITE TOP A view of the Hôtel Lambert on the eastern tip of the Île Saint-Louis. In the 1740s, the Marquise du Châtelet and Voltaire, her lover, used it as their Paris residence.

ABOVE The residence where Voltaire exited this world stage left now hosts a restaurant.

OPPOSITE BOTTOM Cafe Le Procope boasts a desk supposedly used by Voltaire.

> 66
>
> I can never tire of speaking of the bridges of Paris. By day and by night have I paused on them to gaze at their views; the word not being too comprehensive for the crowds and groupings of objects that are visible from their arches.
>
> 99
>
> James Fenimore Cooper

RIGHT The Beaux-Arts-style Pont Alexandre III, with its Art Nouveau lamps, cherubs, nymphs and winged horses is the most ornate in Paris.

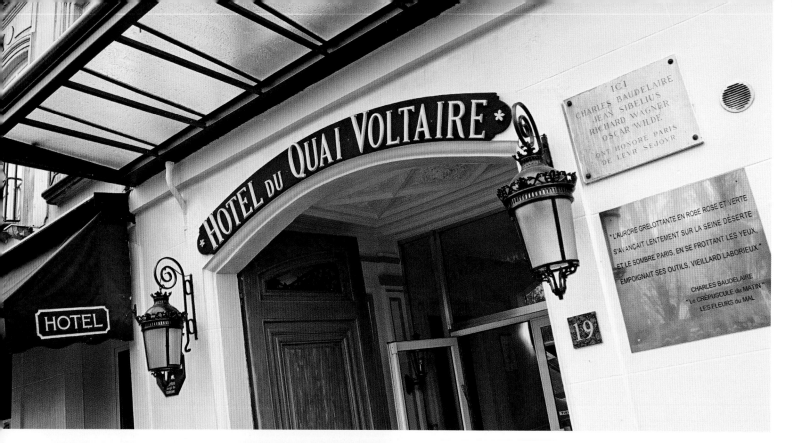

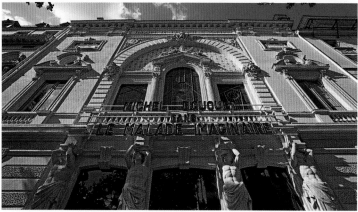

ABOVE A plaque outside the Hôtel Voltaire commemorates former residents Wilde, Baudelaire and composers Richard Wagner and Jean Sibelius.

LEFT Wilde visited Sarah Bernhardt who had taken a lease on the Porte Saint-Martin theatre and was appearing in *Macbeth*.

OPPOSITE A dashing portrait of Wilde from 1882 by Napoleon Sarony.

Oscar Wilde

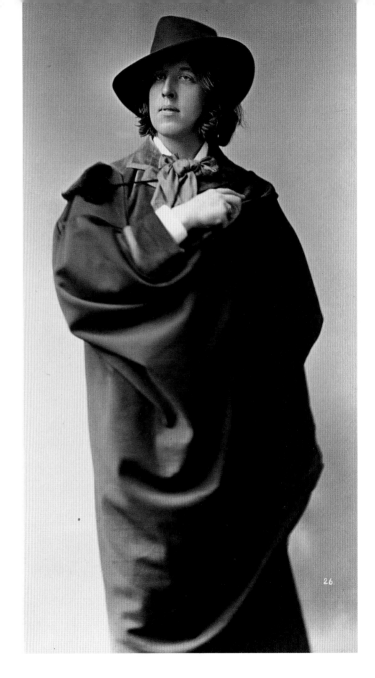

Oscar Wilde's three lengthy stays in Paris were at widely different stages of his career. He arrived in Paris in January 1883 as the prince of the Aestheticism movement. His year-long tour of America, organised by Gilbert & Sullivan impresario Richard D'Oyly Carte, had been a triumph. He was the talk of London and New York and now he was turning his attention to Paris, declaring that 'no modern literature exists outside France'. He booked into the Hôtel Voltaire, patronised by Charles Baudelaire, and took to carrying an ivory and turquoise topped walking cane like his literary hero Honoré de Balzac. He duly did the rounds of literary salons, calling on the divine Sarah Bernhardt at the Porte Saint-Martin theatre where she was playing Lady Macbeth. Wilde was one of the few to praise the production, and the great French actress would be the inspiration for his biblical play *Salomé*.

He returned in 1891 as the notorious author of *The Portrait of Dorian Gray* which had shocked Victorian society and enjoyed his elevated status in the literary salons. Returning to his hotel one evening, having spent the evening discussing the depiction of biblical figure Salome over the years, he picked up a blank notebook and started writing down his musings in French. Wilde was convinced the play, which was published in France in 1891, would see him admitted to the Académie Française.

His final visit came after his release from Reading Gaol in 1897, when he sailed immediately for Dieppe. After spells in nearby Berneval le Grand and Naples he moved to Paris. The impoverished author was asked to leave the Hôtel Marsollier at 13 Rue Marsollier for failing to pay his bill, though the modern Hôtel Marsollier still trades on the connection with a plaque by the door. He ended up at the Hôtel d'Alsace at 13 Rue des Beaux-Arts, where a sympathetic owner extended him credit and gave

special treatment to his financially embarrassed guest. The days of visiting literary salons were over, he drank Courvoisier brandy and wandered the boulevards alone, avoiding English tourists for fear of recognition, his health failing. On one of his trips outside he confessed, 'My wallpaper and I are fighting a duel to the death. One of us has to go.'

Wilde died of meningitis at the hotel in November 1900. Today, the renamed L'Hôtel is rated as one of the world's finest, and guests can book the room where he passed away, now known as the Oscar Wilde Suite.

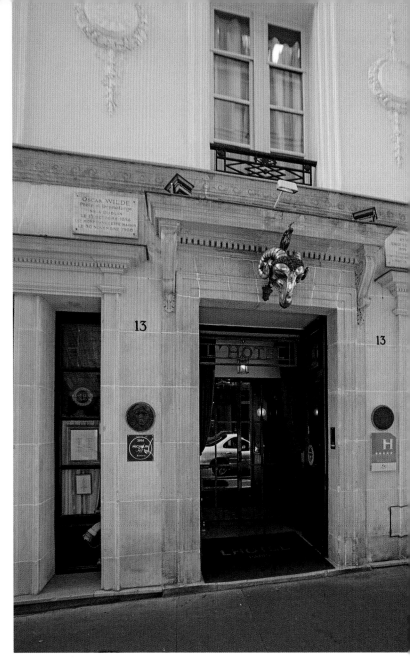

ABOVE LEFT The Oscar Wilde suite at L'Hôtel.

ABOVE Hôtel d'Alsace as it looked in the 1920s.

RIGHT Today, L'Hôtel is one of the most highly rated hotels in Paris, if not Europe, and nobody fights duels with the wallpaper.

Richard Wright

Richard Wright was already a successful novelist when he moved to Paris in 1947, having published *Native Son* (1940) and the best-seller *Black Boy* (1945), drawing on his childhood in Mississippi. He had been a member of the Communist Party up until 1942 and was friends with both Albert Camus and Jean-Paul Sartre, whom he had met in New York.

On arrival in Paris with wife Ellen, who was his literary editor, the mixed race couple threw themselves into the intellectual life of the capital, though Wright was always wary of monitoring from the CIA because of his communist past. He rented a large apartment at 14 Rue Monsieur le Prince and became the unofficial kingpin of expatriate Black Americans in Paris, holding court at Café Monaco and Le Tournon. He was generous with his time, welcoming James Baldwin to Paris and making introductions for the young writer. Sylvia Beach, whose memoirs Wight encouraged her to write, told her sister: 'Of all the writers I have known, he is the most unselfish and thoughtful...Fellas like Hemingway appear uncouth beside Dick Wright.'

Although he had become a French citizen he still felt beholden to US authorities for the renewal of his American passport, and the American consulate regularly pressed him for information on communist activity. However, one of the things that stung him most was criticism by James Baldwin in the magazine *Zero*, questioning his earlier novels. He was contemplating a move to London when he died of a heart attack in 1960 at the age of 52, with conspiracy theories abounding about the role of the CIA and the Russians in his untimely demise.

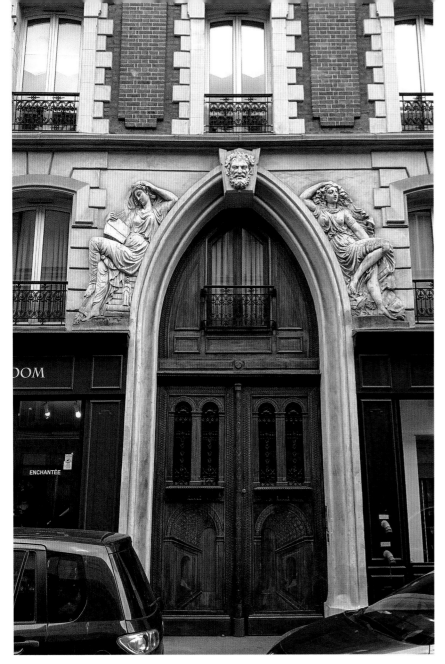

ABOVE Wright's local bookshop was just down the street at 60 Rue Monsieur le Prince, the Librairie du Zodiaque. 'Puf' is an acronym for *Presses universitaires de France*, which now runs the store.

LEFT The Wright family could afford accommodation at the elegant 14 Rue Monsieur le Prince.

OPPOSITE Wright walking in the Luxembourg Garden in 1959, a short stroll from Café Le Tournon.

"

The cafés are most agreeable places, and ones
where one finds all sorts of people of different
characters. There one sees fine young gentlemen,
agreeably enjoying themselves; there one sees
the savants who come to leave aside the laborious
spirit of the study; there one sees others whose
gravity and plumpness stand in for merit.

Louis, Chevalier de Mailly,
in *Les Entretiens des cafés*, 1702

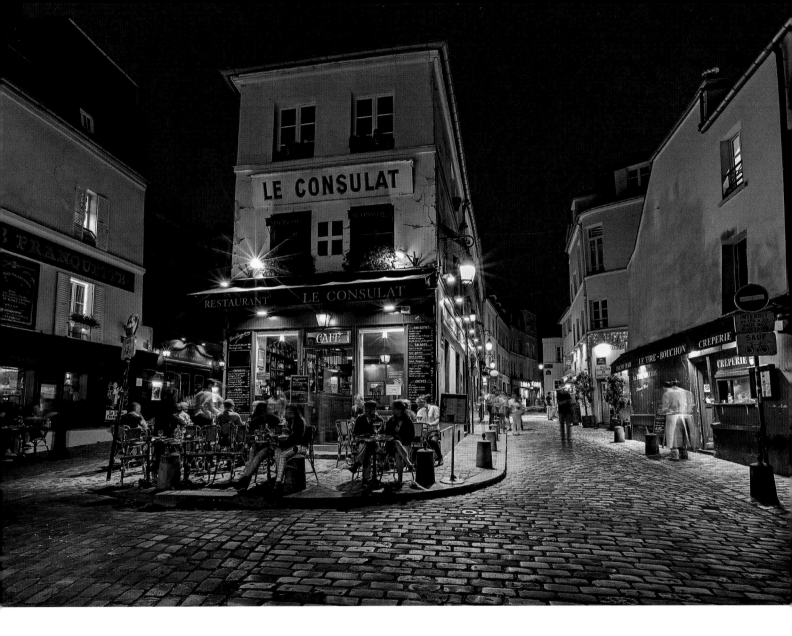

RIGHT Le Consulat restaurant on Rue Norvins in Montmartre.

CAFÉS AND RESTAURANTS

La Coupole

102 Boulevard du Montparnasse

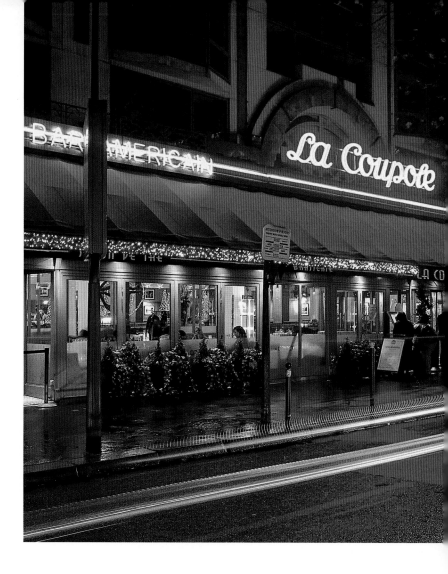

A literary favourite among the quartet of brasseries near Carrefour Vavin (the crossroads where Boulevard Raspail crosses Boulevard du Montparnasse) is La Coupole. A celebration of classic Art Deco, this vast establishment, with over 600 covers, has an army of waiters, mosaic floors, period mirrors, lamps and lightshades, and a forest of painted square pillars spread throughout. It has been entertaining customers – and in the early days particularly writers – since December 1927.

Georges Simenon, the Belgian creator of the fictional detective Jules Maigret, was one of the first regulars, along with his girlfriend, the American dancer Josephine Baker, who used to bring her pet cheetah with her, to the great surprise of other customers. Later, Albert Camus ate here, famously celebrating his Nobel Prize in literature with fellow writers at one of the tables.

Today, La Coupole is often inundated by tourists, but the Bar Americain has lost none of its panache. Downstairs there is a dancefloor for when the cocktails have hit the spot. The famous La Coupole lamb curry has been on the menu ever since the opening almost a century ago.

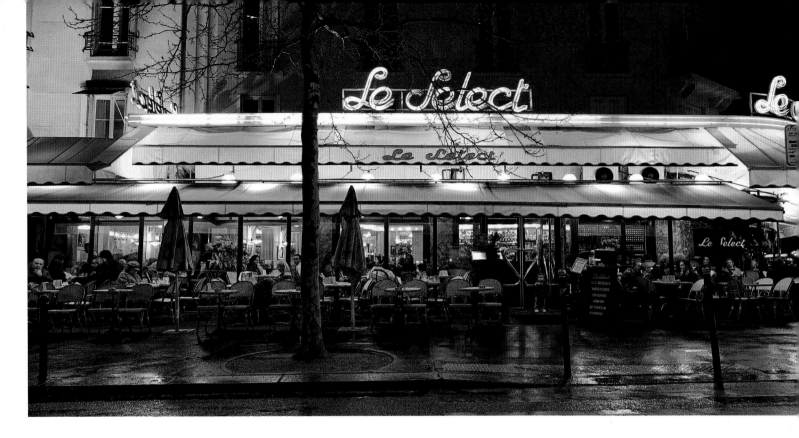

Le Select

99 Boulevard du Montparnasse

Across the boulevard from La Coupole is another café of the Montparnasse quartet, Le Select. Rowdiness was not unknown at the bar, since it was the first Montparnasse establishment to serve alcohol 24 hours a day, with 'Ouvert toute la nuit' emblazoned proudly on the café awning. It was first opened in 1925, by the Pléget family, and along with the other Montparnasse cafés, became a favourite hangout for European and American expatriate writers. In Ernest Hemingway's debut novel, *The Sun Also Rises* (1926), Jake Barnes, the novel's narrator drops into Le Select four times. Three decades later, writer James Baldwin wrote a large part of *Giovanni's Room* (1953) in the café. Today, Le Select preserves its 1920s-style décor and its terrace awning, and offers a wide-ranging food and drinks menu, including almost 70 whiskies.

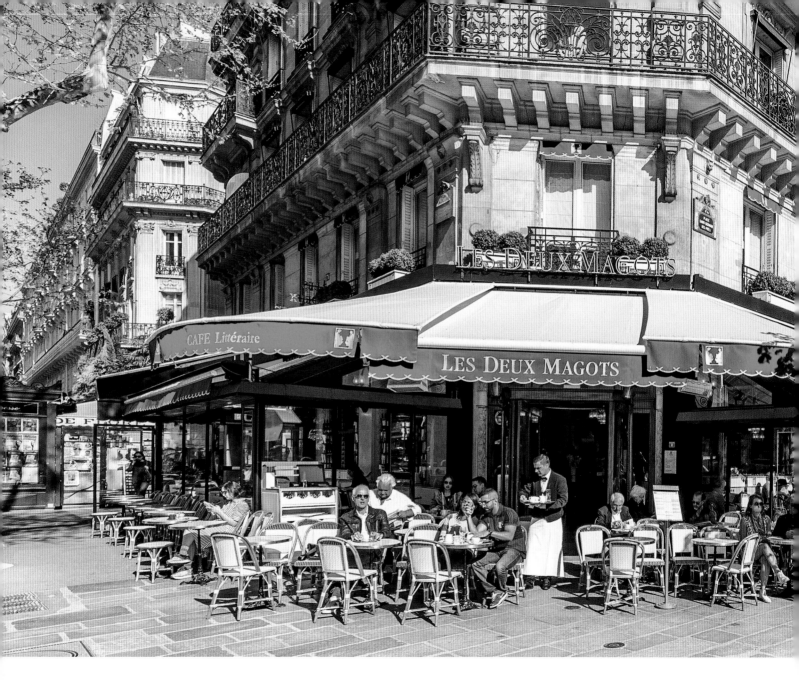

Les Deux Magots
6 Place Saint-Germain-des-Prés

In both English and French, a magot is an oriental figurine. The café name is a reference to the picture on the sign that used to hang outside a fabric and novelty goods shop on Rue de Buci. By 1873 the store had moved to Place Saint-Germain-des-Prés and later became a café. In the late 1800s it was the favoured drinking hole of poets Paul Verlaine, Arthur Rimbaud and Stéphane Mallarmé. In the years before absinthe was banned across France, plenty of the potent green spirit was consumed here, especially by Verlaine.

By the 1920s, the likes of James Joyce, André Gide, Jacques Prévert and Ernest Hemingway were regularly meeting in the café. Then came the surrealists – according to American writer Janet Flanner, they would all sit at their club table facing the front door, from where they could throw insults at any new arrival whose opinions they disagreed with. Finally, the existentialists – particularly Jean-Paul Sartre and Simone de Beauvoir – took up occupation.

In 1933 the café owners launched a literary prize, Le Prix des Deux Magots, a response to the Prix Goncourt which they considered too academic. It has been awarded ever since to new books, often rather unconventional ones.

Today, the two Chinese statues still stand sentry on the wall in the café's interior. Outside, part of Place Saint-Germain-des-Prés has been renamed Place Sartre-Beauvoir in honour of the famous philosophy partners who drank and shared ideas here.

Le Dôme

108 Boulevard du Montparnasse

Bohemians and artists had been congregating around Montparnasse since the late 1800s. But it was during the 1920s that the quarter's vibrant cafés and brasseries really came into their own, their clientele often swelled by American writers escaping prohibition in the United Sates, and desperate to drink. And, *ciel mon mari*, how they drank!

Le Dôme, on Boulevard du Montparnasse, was one of the biggest and most popular hang-outs; back then its terrace was three times the size it is today. First opened in 1897, its heyday was after World War I, when dozens upon dozens of writers, artists and journalists would spill out on to the pavement tables. 'Les Dômiers' was the term given to them. Among the writers who frequented the café were Samuel Beckett, Henry Miller, Anaïs Nin, Ezra Pound and, of course, the ubiquitous Ernest Hemingway. The latter resented the restaurant's popularity, and disliked many of its trendy regulars; however, he devoted an entire chapter of his 1964 memoir *A Moveable Feast* to his meeting there with the Bulgarian painter Jules Pascin.

Nowadays, in charge of the kitchen is a Michelin-starred chef from Japan. But he's conscious of the history – the main menu is called Menu Ernest. And the restaurant décor – with nods to surrealism, expressionism and cubism – is respectful of the artists who once ate and drank there.

In honour of its great literary and artistic heritage, in 2018 the restaurant launched a prize ceremony called le Prix Double Dôme, with awards given to French musicians, writers and visual artists.

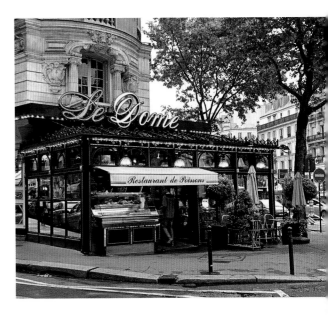

OPPOSITE Among Le Dôme's celebrated 'Dômiers' were occultist Aleister Crowley, artist Paul Gauguin and Vladimir Lenin.

Restaurant Drouant

16-18 Rue Gaillon

ABOVE Photographing the winner of the Prix Goncourt has been a bit of a scramble in the past. Now the winner gets to pose at a first-floor window. Jean-Paul Dubois won in 2019 with *Tous les hommes n'habitent pas le monde de la même façon* (*Not all men inhabit this world the same way*).

Few would deny that the Prix Goncourt is French literature's most prestigious award. Since 1903 it has been lionising France's greatest men and women of letters. Although the current prize is a symbolic reward of just €10, the resulting fame and book sales conferred on the winning author are enormous. The winning book sells, on average, 400,000 copies. Previous winners include luminaries such as Marcel Proust (1919), Simone de Beauvoir (1954), Patrick Modiano (1978), Marguerite Duras (1984), Michel Houellebecq (2010) and Leïla Slimani (2016).

Drouant, an upmarket restaurant in the second arrondissement, plays a leading role every year in the Prix Goncourt. Ever since 1914, in a first-floor salon called the Salon Goncourt, the jury for the award regularly meet and vote for the winners. In 2014, to commemorate the prize's 100th anniversary, quotes from the jury members at the time were inscribed on the restaurant's interior walls.

The business itself was established back in 1880 by Charles Drouant as a bar and tobacco shop, but quickly made a name for itself thanks to the fresh oysters that were regularly delivered from Brittany. In 2018, this glorious Art Deco restaurant was given a major facelift. The plaster casts on the ceiling of the main dining area were remodelled, stone mosaic floors were put down, the seating was covered with yellow velvet, and walls of one of the salons were decorated by Italian artist Roberto Ruspoli. Even the restaurant's greatest feature – the famous mirrored Ruhlmann staircase – was renovated. It is from this staircase that the Prix Goncourt winner is announced every year to a crush of anticipatory media and publishing bigwigs.

The restaurant also hosts the jury of another literature prize called the Prix Renaudot, and runs a literature salon for members called Le Cercle Drouant, staging literary dinners, conferences and talks from authors.

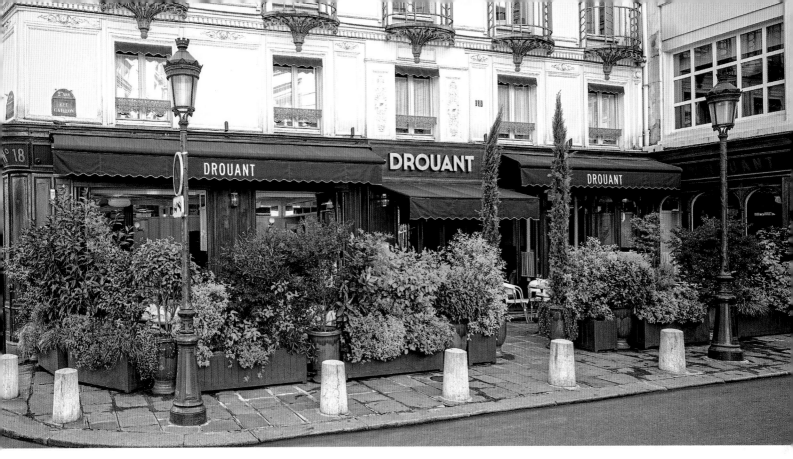

ABOVE The Drouant restaurant is inextricably linked with the Goncourt literary prize and now has many imitators.

LEFT The winner gets a cheque for ten euros, but the reputational value of a Prix Goncourt is priceless.

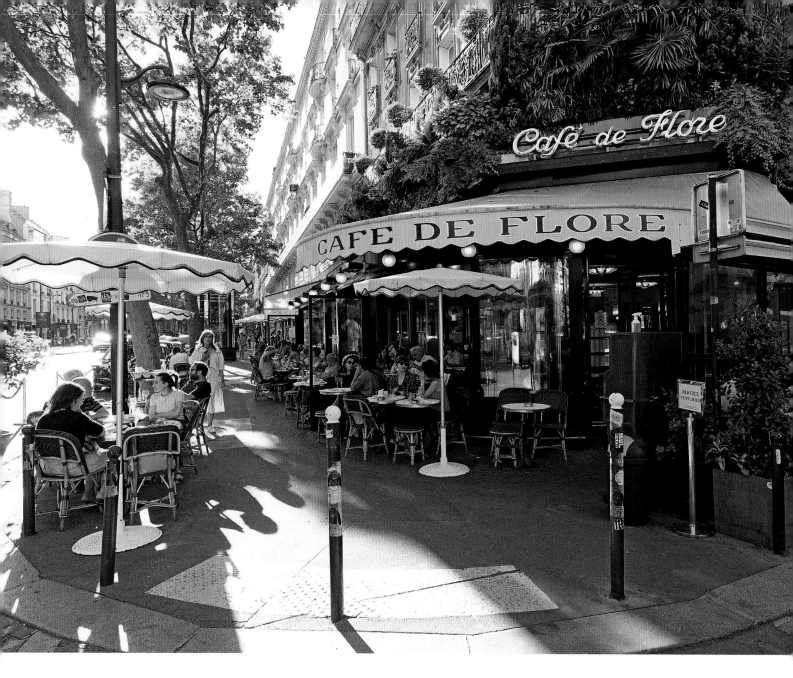

Café de Flore

172 Boulevard Saint-Germain

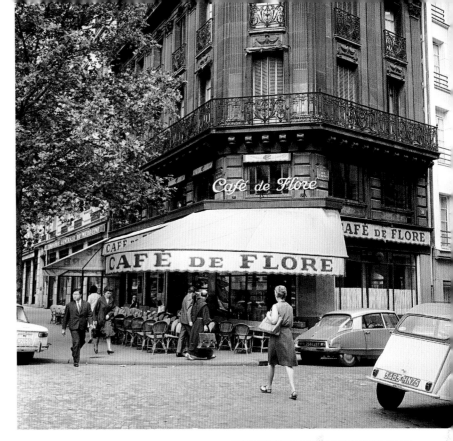

Café de Flore, in Saint-Germain-des-Prés, is one of the older cafés in Paris, although no one is quite sure exactly when it first opened. The restaurant hazards a guess at 1887. What is certain is how it earned its name: on the other side of the boulevard once stood a sculpture of Flora, the Roman goddess of flowers and spring.

From the very start it was a favoured drinking hole for Parisian writers. Novelists Joris-Karl Huysmans and Remy de Gourmont, who spearheaded the Decadent movement of the late nineteenth century, were among the first regulars. Around the same time, on the café's first floor, the right-wing author and politician Charles Maurras – later jailed for life for his role in the Dreyfus Affair – wrote his political memoir *Au Signe de Flore* and launched the far-right nationalist newspaper *La Revue d'Action Française*.

After Guillaume Apollinaire became a regular, just before World War I, Café de Flore soon became a meeting place for the Surrealists, usually buoyed by far too much alcohol. From then on, through the two World Wars and as the twentieth century progressed, the café became a club and sometime office for writers, intellectuals, publishers, painters and filmmakers of every ilk imaginable. Among the more famous drinkers were Pablo Picasso, Albert Camus, Jean-Paul Sartre, Simone de Beauvoir, Marguerite Duras and, after World War II, Truman Capote and Lawrence Durrell.

In more modern times, Café de Flore lost none of its showbiz sparkle. Poet and town drunk Serge Gainsbourg used to knock back a double pastis 51, which he nicknamed the 102. In 1994 the café launched its own annual literary prize, Prix de Flore. Each year the winning author receives €6,150 in prize money and a free glass of Pouilly-Fumé at the café every day for a whole year.

ABOVE AND OPPOSITE A 'Then and Now' comparison between the Café de Flore of 1971 and 2022, when there was considerably more foliage.

"

The café glittered all over with lights.
The new gas-jets cast their incandescent novelty all
around, brightening the whiteness of the walls, the
dazzling planes of a multitude of mirrors, the gilt of all
the mouldings and cornices – the nymphs and goddesses
balancing baskets of fruits and pâtés and game on their
heads, multicoloured pyramids of ice – all history and
mythology were exploited in the service of gluttony.

Charles Baudelaire

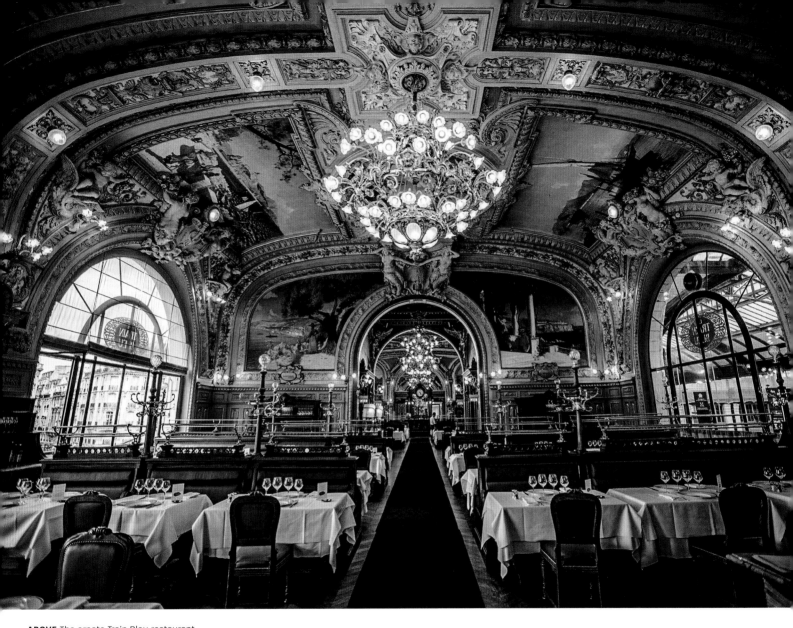

ABOVE The ornate Train Bleu restaurant
at the Gare de Lyon.

La Closerie des Lilas

171 Boulevard du Montparnasse

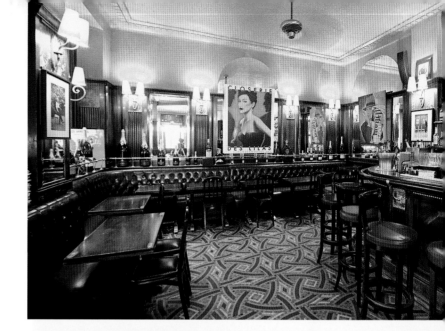

It's thanks to this restaurant on Boulevard du Montparnasse that we are able to enjoy Ernest Hemingway's classic modernist novel *The Sun Also Rises*. The writer, keen to escape the many other American expatriates in Paris, used it as his de facto office while rewriting large sections of the book. He was particularly industrious in the early mornings, appreciating the warmth of the restaurant interior in winter, and the shaded terrace seats during the spring and autumn, from where he often gazed at the nearby statue of Marshal Ney, one of Napoleon's military commanders.

La Closerie des Lilas first opened in 1847, and quickly established itself as the perfect meeting spot for artists and working spot for writers. Poets such as Paul Verlaine, Charles Baudelaire and Guillaume Apollinaire scribbled and spilled drinks on its tables, as did novelists Émile Zola, André Gide, Oscar Wilde, Ezra Pound, Jean-Paul Sartre, Henry Miller and F. Scott Fitzgerald. It was here, in the banquet room upstairs, that the Surrealists finally extinguished the Dadaist movement. And it was here, on the restaurant terrace, that Fitzgerald finally persuaded Hemingway to read his manuscript of *The Great Gatsby*.

But Hemingway is the name the owners still dine out on most. Indeed, a tiny brass plaque marks the great American novelist's favourite seat, while a fillet of Beef Hemingway is always on the menu.

Nowadays, with its restaurant, brasserie, piano bar, red faux-leather booths, zinc bar and low lighting, the restaurant is unashamedly old-fashioned. Since 2007, it has staged a literary prize for women writers called the Prix de la Closerie des Lilas.

LEFT Hemingway and Fitzgerald would meet regularly at the Lilas, where 'Hem' wrote his classic short stories, 'Big Two-Hearted River' and 'Soldier's Home'.

ABOVE As time has gone on, the 'enclosure of lilacs' has developed further out into the Boulevard du Montparnasse.

Brasserie Lipp

151 Boulevard Saint-Germain

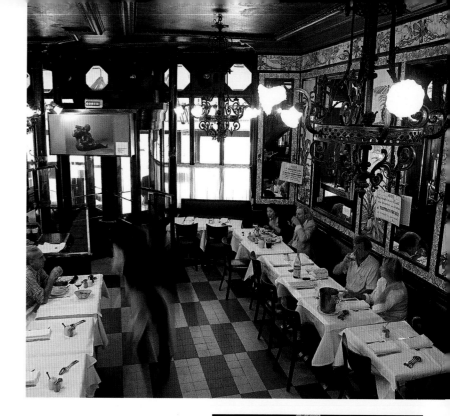

This brasserie on Boulevard Saint-Germain sponsors an annual literary prize called the Prix Cazes, which seeks to reward authors who haven't previously been successful in literary competitions. Created in 1935 by former owner Marcellin Cazes, it has been staged annually ever since. Appropriately so, since this restaurant in Saint-Germain-des-Prés has been hosting writers and intellectuals for much of its existence.

This storied restaurant was first opened in 1880 by Léonard Lipp, under the name Brasserie des Bords du Rhin. Fleeing the German occupation of his homeland, Alsace, Lipp came to Paris, offering the food and drink typical of eastern France. The beer was particularly popular. His customers referred to the restaurant as Chez Lipp, so that eventually he changed its name to the current one.

By 1918, Marcellin Cazes had taken over. His wife took charge in the kitchen, retaining the popular Alsatian dishes, while the décor became a lot more ostentatious, with painted ceilings, tiled murals and purple moleskin seats.

It was actors who formed the first group of creatives to frequent Lipp, and that was thanks to a nearby theatre group called Vieux-Colombier. Then followed the writers; Hemingway loved the beer and sausages. In 1949, American writers James Baldwin and Richard Wright famously fell out at Lipp over their differing attitude to protest literature.

In the post-war era, Marcellin's son Roger at the helm, Lipp began to attract France's political elite, the dining area often buzzing with uproarious political discourse. Occasionally, the boss would sound a bell in order to restore calm. Over the years the likes of Charles de Gaulle, Georges Pompidou, François Mitterrand and Jacques Chirac all dined here.

ABOVE Nowadays, Brasserie Lipp is still a favourite for many in the publishing industry, mainly because publishing houses such as Flammarion, Editions de Minuit, Gallimard and Hachette are all located conveniently nearby.

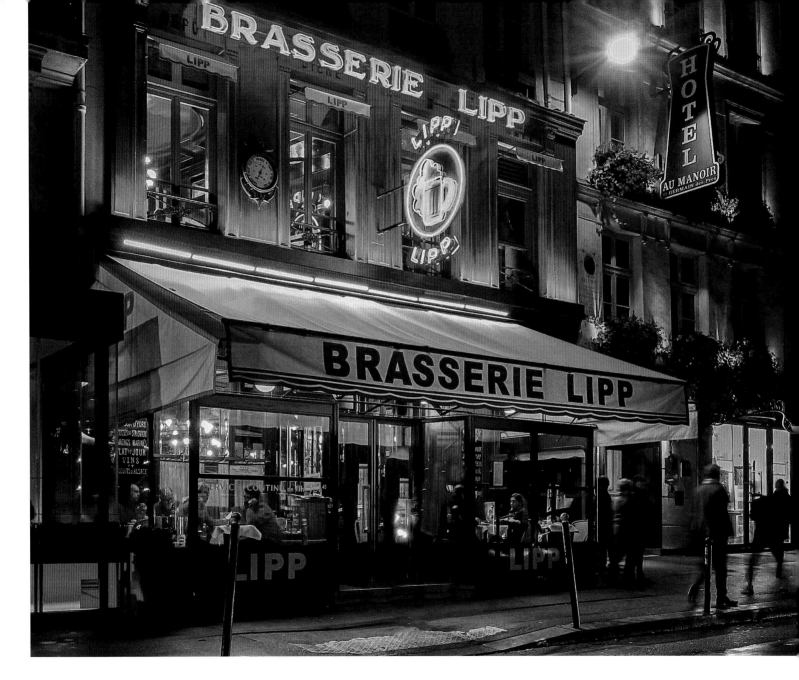

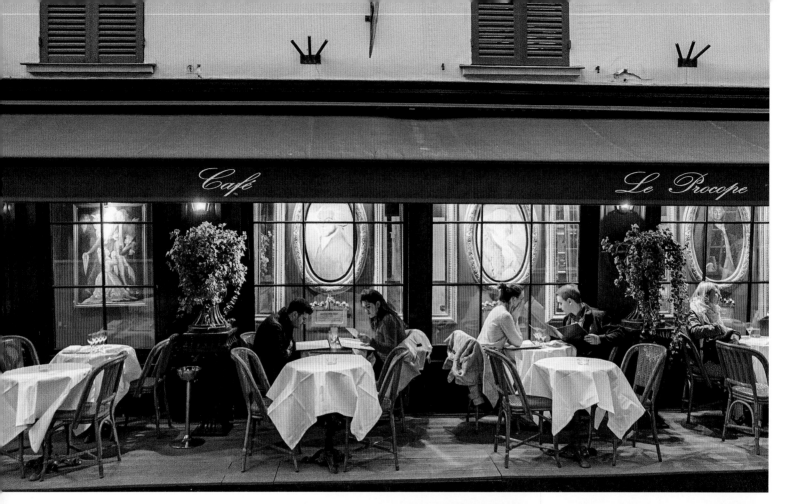

ABOVE Louis-Sébastien Mercier noted of Voltaire: 'While composing, he was looking towards the French Academy, the public of Comédie-Française, the Café Procope, and a circle of young musketeers. He hardly ever had anything else in sight.'

FAR RIGHT In 1939 Procope was luring customers in through the door with an offer of a *prix fixe* meal for 9 Francs.

Le Procope

13 Rue de l'Ancienne Comédie

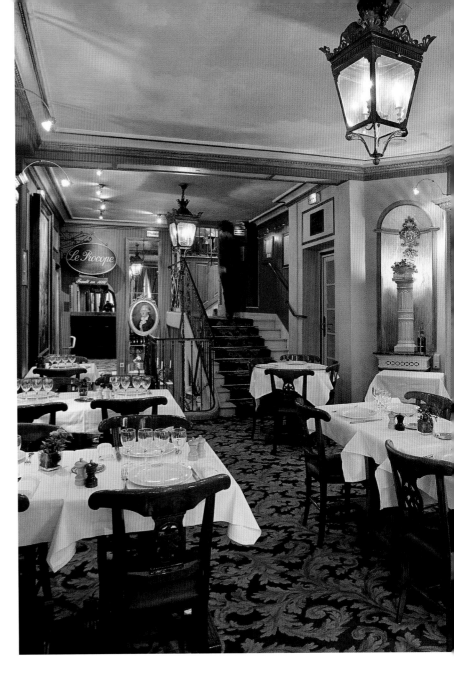

Established in 1686, Café Procope, in Rue de l'Ancienne Comédie in the sixth arrondissement was opened by the Sicilian chef Francesco Procopio dei Coltelli, or to use his French name, François Procope. After the Comédie-Française opened its doors in a theatre across the street from his café it became a destination for intellectuals and the artistic and literary community of eighteenth- and nineteenth-century Paris. Actors gossiped with playwrights and poets, fuelled by the great new drink – coffee. Voltaire was said to drink 40 cups a day, mixed with chocolate as he worked from a desk at the Procope. *Narcisse* was the last of seven plays written by Jean-Jaques Rousseau during his stay in Paris from 1742 to 1752, and before its opening night he retired to the Procope, declaring how boring it all was on stage now that he had seen it mounted. Napoleon took Josephine there, and Thomas Jefferson took Ben Franklin to the Procope as they worked on details for a treaty with France that would prove decisive in the American Revolution. More significantly to the French literary community it was the birthplace of the great *Encyclopédie*, conceived by Denis Diderot and Jean le Rond d'Alembert. The original café closed in 1872 and did not reopen until the 1920s, when it was known as Au Grand Soleil. That is, until someone realised the deep history of Procope and shrewdly changed it back.

La Rotonde

105 Boulevard du Montparnasse

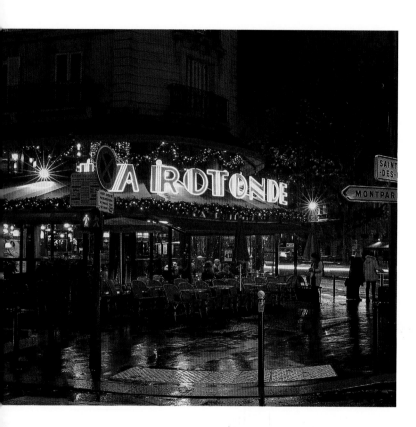

ABOVE For lovers of literary cafés the Boulevard du Montparnasse offers La Rotonde, Le Select, La Coupole and Le Dôme within metres of each other for an evening of hedonistic indulgence, whatever the weather.

If you need proof of La Rotonde's place in Parisian café culture, then consider this: in 2017, after winning the first round of the French presidential election, Emmanuel Macron celebrated by popping champagne corks with his supporters at this brasserie on Boulevard du Montparnasse.

When it first opened in 1904, it was a small and insignificant bar for workmen who had finished their shifts for the day. Then, in 1911, new owner Victor Libion expanded it, opening a large terrace in front, which became known as Raspail Plage, after the Boulevard Raspail that it overlooked.

Libion was generous to his clientele. The story goes that, in the early days, he allowed struggling artists to frequent the café for hours, in return for buying just a single cup of coffee for ten centimes. And he would turn a blind eye when they pinched pieces of bread from the baguette basket. He would accept paintings (or even drawings on café napkins) as payment for outstanding bills, so that the walls of the café were adorned with art, some of which, today, would command eye-watering prices. When boozy diners fell asleep at the table, the waiters were instructed not to wake them; when fights broke out, which they often did, the police were rarely called.

It was in the apartment building above La Rotonde that future feminist writer Simone de Beauvoir was born in 1908, so that the brasserie naturally became a major feature of her upbringing. She later described the building in detail in her 1958 autobiography *Memoires d'une Jeune Fille Rangée* (*Memoirs of a Dutiful Daughter*).

Other writers who frequented included Gustave Moreau, André Breton, Georges Simenon, Jean Cocteau, F. Scott Fitzgerald, Ernest Hemingway, Anaïs Nin and Henry Miller. Miller first declared his undying love for Nin at La Rotonde, while Hemingway, in his 1926 novel *The Sun Also Rises*, claimed that whichever Montparnasse café you asked a taxi driver to take you to, he always dropped you in front of La Rotonde.

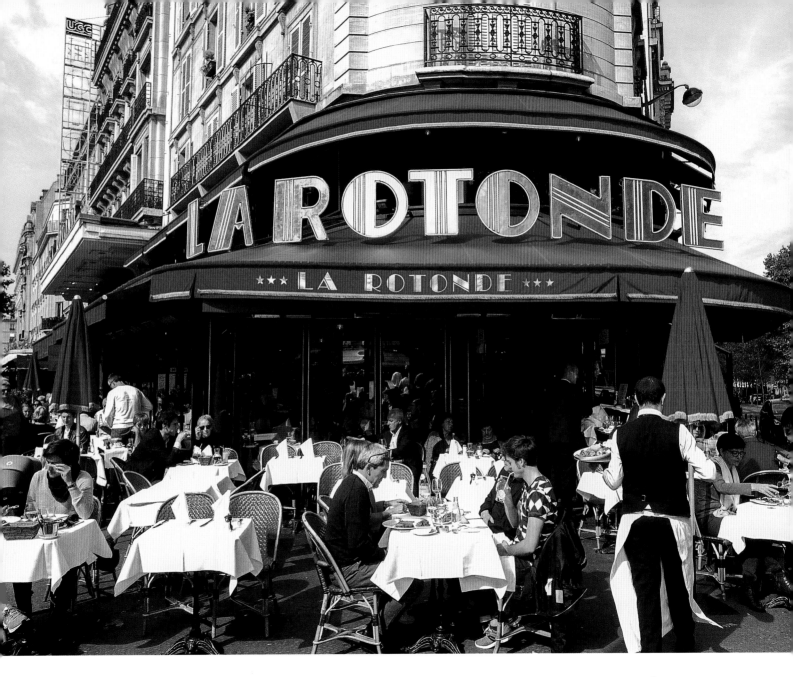

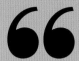

It was late; like a newly struck medal
The full moon spread its rays,
And the solemnity of the night streamed
Like a river over sleeping Paris.
And along the houses, under the porte-cochères,
Cats passed by furtively,
With ears pricked up, or else, like beloved shades,
Slowly escorted us.

Charles Baudelaire, *Les Fleurs du Mal*

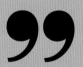

Café Le Tournon

The Rue de Tournon leads up to the Palais Luxembourg, and a stone's throw away is the Café Le Tournon. Either side of World War II it was a place for exiles – to live in the hotel upstairs – and to write in the café on the street. In the 1930s it was home to Jewish authors forced from their homeland in Germany and Austria, whose books had been banned and burned by the Nazis. They included Joseph Roth, born in the Ukraine when it was part of the Habsburg Empire and whose 1932 novel *The Radetzky March* is one of the most significant novels written in the German language. In 1939, after six years of drink-fuelled remorse at his situation, he learned that his friend, the playwright Ernst Toller, had committed suicide. He collapsed in the Tournon and died several days later. A plaque on the wall outside commemorates his life in Paris.

Post World War II the Tournon became a hub for English-speaking authors, first with the writers and editors of avant-garde magazine *Merlin*, and more significantly with Black writers and musicians led by Richard Wright. A move to Paris allowed them the freedom and equality denied in their home country. In Paris they weren't viewed as Black; they were simply viewed as Americans. James Baldwin, who arrived in Paris in 1948 and was mentored by Wright, expressed it neatly in his short story 'Equal in Paris' (1955). Baldwin had been given some bed sheets taken from another hotel, and when the French police called to investigate the stolen goods he anticipated the kind of treatment he could expect in his native Harlem: 'That evening in the commissariat I was not a despised black man... For them I was an American.' At first a tight-knit community, with Duke Ellington, writer Chester Himes and cartoonist Ollie Harrington at the core, the group eventually fell out after suspicions of CIA monitoring clouded their relationships.

OPPOSITE AND ABOVE Three ages of Café Le Tournon: as it looked in Baldwin's time, more recently with the plaque to Joseph Roth above, and after a 2022 update.

Le Grand Véfour

17 Rue de Beaujolais

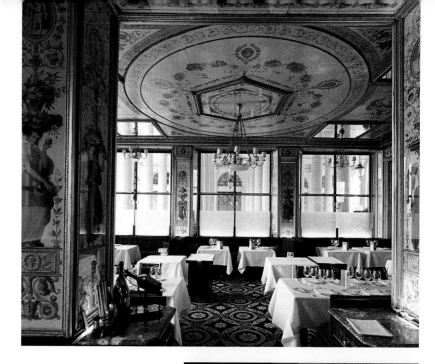

Just before Christmas in 1983, a bomb exploded outside the front of Le Grand Véfour, one of Paris's finest restaurants, injuring a dozen diners. 'I am ruined,' said the then chef Raymond Oliver. No culprit was ever apprehended, and no one ever claimed responsibility for the attack. It was an ignoble act inflicted on a very noble Parisian establishment – one that has for hundreds of years combined two of France's greatest pleasures: gastronomy and literature.

Arguably the first of Paris's grand restaurants, Le Grand Véfour, beneath the arcades of the Palais-Royal, in the first arrondissement, opened its doors in 1784 under its original incarnation of Café de Chartres. Antoine Aubertot was the epicure (and soft drinks merchant) who founded it. There were several subsequent owners until the arrival, in 1820, of Jean Véfour, who gave the restaurant its current name. According to the classic French food encyclopedia *Larousse Gastronomique*, it was christened Le Grand Véfour in order to distinguish it from Jean's brother's nearby restaurant Le Petit Véfour, which eventually closed in 1920.

The restaurant's literary reputation was established early on, with customers meeting to read English and German newspapers. In the late 1800s a regular group of five diners at Le Grand Véfour became known as Les Diners des Cinq: they were French novelists Gustave Flaubert, Émile Zola,

ABOVE Today it is chef Guy Martin who maintains the gastronomic legacy of the restaurant's predecessor Raymond Oliver.

OPPOSITE The interior decor has changed little since it was first conceived between 1784-1785.

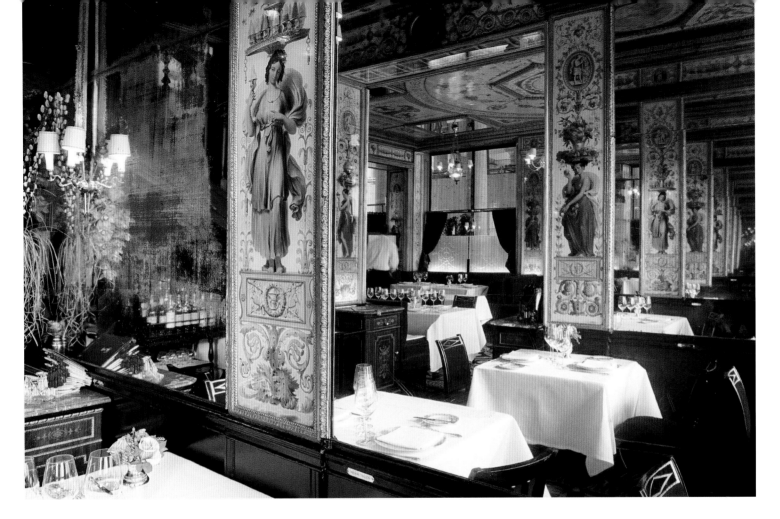

Alphonse Daudet, Russian writer Ivan Turgenev (author of *Fathers and Sons*), and Edmond de Goncourt (founder of the Académie Goncourt for whom the Prix Goncourt is named). Their own nickname for the group was *Le Diner des Auteurs Sifflés* (the dinner of the authors who have been booed), a reference to the fact that all had created unpopular works at one time or another.

By the turn of the century, Le Grand Véfour was running into financial difficulties so that by 1905 the restaurant had been downgraded to a café. Quelle horreur! They even resorted to offering paper napkins.

After World War II it was Louis Vaudables, owner of the famous Maxim's, who came to the rescue, eventually going into partnership with top chef Raymond Oliver. Among Oliver's fans were writers such as Colette (who lived nearby) and Jean Cocteau who, in turn, encouraged the likes of Jean-Paul Sartre, Simone de Beauvoir, Jean Genet and André Malraux to bring their custom.

Nowadays the restaurant interior looks very much like it did back in Véfour's heyday, with intricate carved panelling, large mirrors, neoclassical frescoes, stucco garlands and ceiling roses.

CEMETERIES

Montparnasse Cemetery

Boulevard Edgar-Quinet

Stroll into the main entrance of Montparnasse cemetery, on Boulevard Edgar-Quinet, in the 14th arrondissement, and you know immediately you're among literary greats. Just to your right, next to the outer wall, is the joint tombstone of Jean-Paul Sartre and Simone de Beauvoir.

Dozens of other great writers have found their final resting place here since the cemetery – Paris's second largest after Père Lachaise – first opened in 1824. Covering 19 hectares, in the south of Paris, it is shaded by over a thousand trees and shrubs, making it the perfect spot for a bookish ramble, even in the summer heat. The eastern section of the cemetery – *petit cimetière* – is kite-shaped, while the western section – *grand cimetière* – is square. Rue Émile Richard splits the two sections, while the entire site is separated into 29 divisions, allowing visitors to find their way around.

ABOVE Fans of Marguerite Duras, leave pens for her.

RIGHT The cemetery as viewed from the observation deck of the 210-metre Montparnasse Tower.

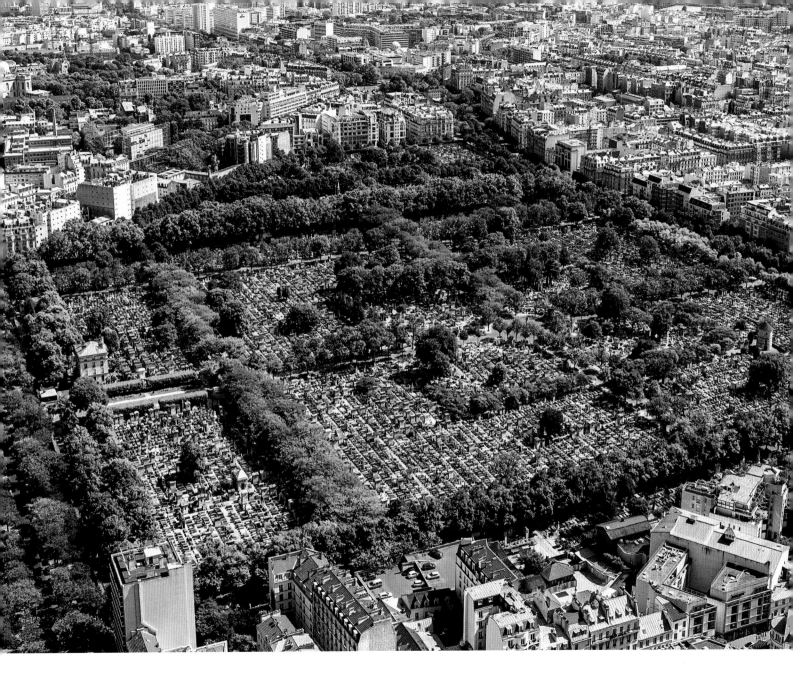

Poet Charles Baudelaire was among the first men of letters to be buried here, in 1867. Most famous for his poem *Les Fleurs du Mal*, he later had a large memorial erected in his honour on the other side of the cemetery, sculpted by José de Charmoy.

After Baudelaire, a veritable *Who's Who* of wordsmiths followed him into the ground, including, among many others, novelists Guy de Maupassant, Joris-Karl Huysmans and Marguerite Duras (the latter always with a pot and saucer full of pens atop her grave), lexicographer Pierre Larousse, symbolist poet Théodore de Banville, Maurice Leblanc (creator of the gentleman thief Arsène Lupin), Susan Sontag, Surrealist poet Robert Desnos, playwrights Samuel Beckett and Eugène Ionesco, and the aforementioned power couple of existentialism, Sartre and de Beauvoir.

One of the most visited graves in Montparnasse is that of French poet-singer Serge Gainsbourg, whose music is still revered three decades after his death. As well as flowers and various trinkets, fans traditionally leave Métro tickets and cabbages on his tomb, references to his 1958 song 'Le Poinçonneur des Lilas' (The Ticket Puncher of Lilacs), and his 1976 album *L'Homme à tête de chou* (*Cabbage Head*).

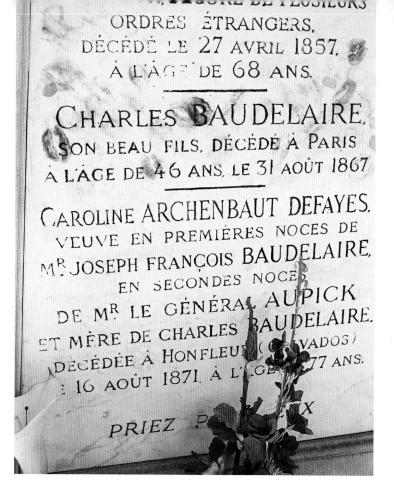

ABOVE Charles Baudelaire was buried in his wife's family plot. *Beau fils* translates as son-in-law.

RIGHT Unsurprisingly, Sartre and de Beauvoir have a simple tombstone.

FAR RIGHT Irish playwright Samuel Beckett is buried with his wife Suzanne Déchevaux-Dumesnil. They died five months apart. In the 1930s he had chosen Suzanne over the heiress Peggy Guggenheim.

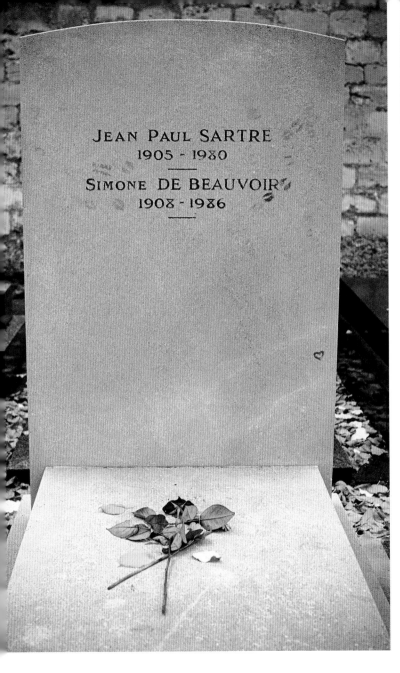

Père Lachaise Cemetery

8 Boulevard de Menilmontant

When it first opened in 1804, the Père Lachaise cemetery proved unpopular. Not simply because of its location out in the east, far from the city centre, but because it hadn't been officially blessed by the church. To attract more corpses, and the income that accompanied them, what was needed was a bit of marketing.

Rather cannily, the cemetery acquired (at least what they claimed were) the remains of Molière, France's greatest playwright, and of Jean de la Fontaine, a famous poet from the same era, transferring them to the new cemetery, amid great fanfare. Later, the remains of playwright Pierre Beaumarchais arrived.

The ploy worked admirably. In its inaugural year there were just 13 graves in Père Lachaise, but by 1830 the grave diggers had their work cut out, with a total of 33,000 bodies buried. Nowadays that figure has increased to over a million – according to the city authorities – not including those cremated or whose remains have since been moved to the ossuary in the Paris Catacombs.

By 1850, writers were choosing to be buried in Père Lachaise of their own accord. In life, Balzac had often enjoyed walking through the cemetery's hilly, shaded walkways, and had even set the denouement of his most famous novel, *Le Père Goriot*, there. In death he became one of its permanent residents.

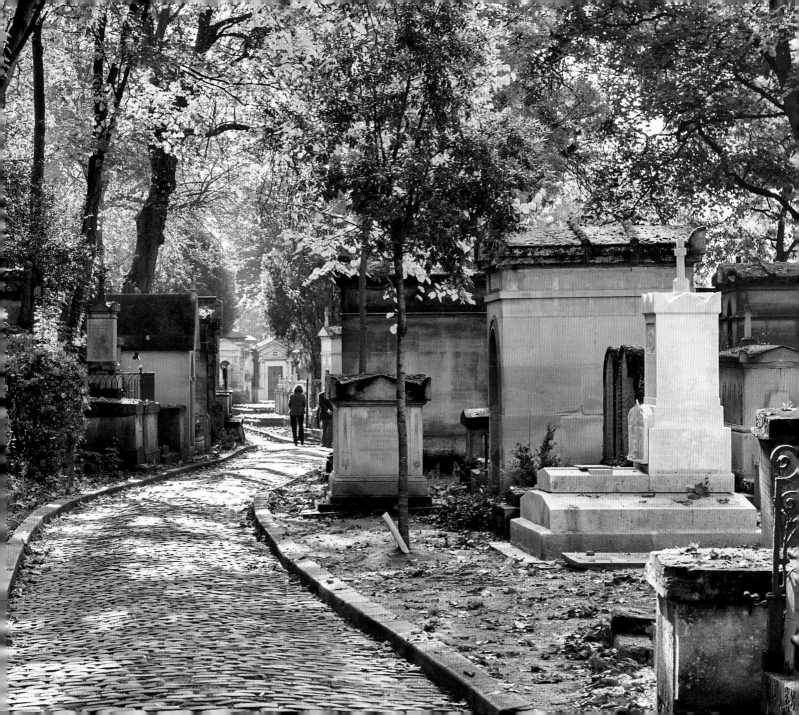

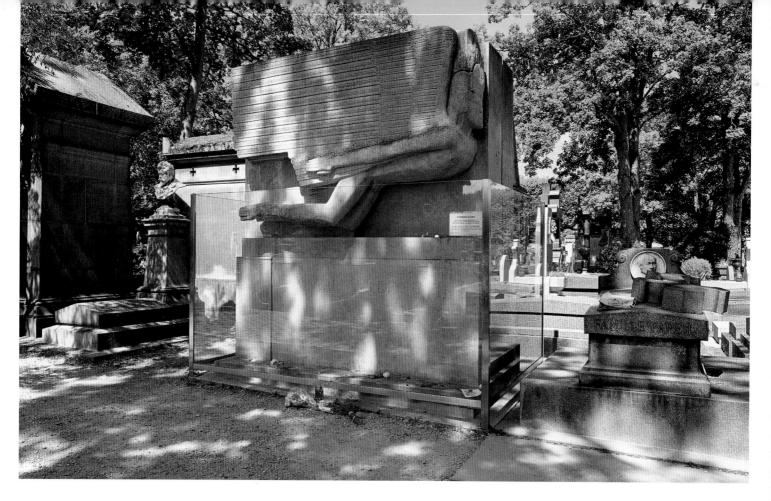

Oscar Wilde, who died in Paris, saddled with debts, was initially buried in a pauper's cemetery south of Paris. But nine years later, friend and art dealer Robbie Ross paid off what Wilde owed and bought him a plot at Père Lachaise, transferring his remains there.

He also commissioned the Anglo-American sculptor Jacob Epstein to create the monument which can be seen today.

Other bookish bodies, or ashes, in the cemetery include those of Marcel Proust, Colette, Raymond Radiguet, Gertrude Stein, Richard Wright, Georges Perec and Paul Eluard. The latter, a supporter of the far left, was buried in an area of the cemetery reserved for communists, near the Mur des Fédérés, where, in 1871, the last surviving Communards were executed after the end of the Paris Commune.

One of Père Lachaise's best-known graves of all – so popular with devoted fans that it has at times required a guardrail to protect it from graffiti – is that of musician-poet Jim Morrison, lead singer of American rock band The Doors. He died of heart failure in Paris in 1971. Even now, over half a century after his death, music fans regularly make the pilgrimage to his tomb, laying flowers, messages and poetry, and playing the songs he himself penned to passers-by.

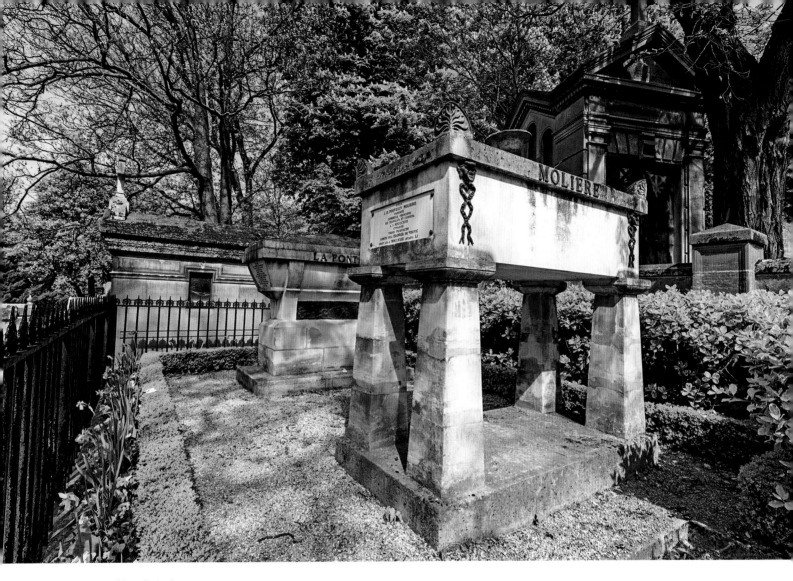

ABOVE LEFT Oscar Wilde's distinctive memorial – now surrounded by a screen to prevent cemetery staff from constantly cleaning the stone of lipstick.

ABOVE The grave of Molière alongside French poet Jean de la Fontaine.

Acknowledgements

Dominic Bliss

With a degree in French literature, and fluency in *la langue de Molière*, Dominic Bliss is a lifelong Francophile. Over the years he has lived in and visited all regions of France, including Paris. He writes for *National Geographic*, *GQ* and is also a senior contributor for *France Today* magazine.

Photo credits: All photos courtesy of Alamy.com with the exception of the following images: Page 6 Charles Loyer/Unsplash, Page 7 Mike Cox/Unsplash, Page 8 John Towner/Unsplash, Page 9 (bottom) Olivia Rutherford, Page 12 Rudy Issa/Unsplash, Page 14 (right) Mathias Reding/Unsplash, Page 19 (bottom) Elisa Michelet/Unsplash, Page 25 Celine Ymlz/Unsplash, Page 28 (top) La Hune Galerie/Librairie/Bracco/teNeues, Page 29 La Hune Librairie/Galerie/teNeues, Page 35 Tschann Librairie/Galerie, Page 40 (bottom right) Brandon Lopez/Unsplash, Page 59 Laila Gebhard/Unsplash, Page 74 Wikimedia/Surane, Page 83 Lola Delabays/Unsplash, Page 84 Chan Lee/Unsplash, Page 89 Wikimedia/Celette, Page 94 Library of Congress, Page 117 Leonard Cotte/Unsplash, Page 119 Library of Congress/Napoleon Sarony, Pages 121 (left) Getty Images, Page 133 Restaurant Drouant, Page 135 (top) Getty Images, Page 148 (top) D.Beretty, Page 160 Olivia Rutherford.

Sandrine Voillet

Sandrine Voillet is a French art historian, tour leader and TV presenter. After obtaining an MA in Art History at the École du Louvre in Paris, she worked in the arts sector in different roles, including work as a curator for a private art collection. In 2007 she presented a three-part BBC series on the cultural history of Paris, *Sandrine's Paris*, with an accompanying book that detailed the art and literary history from over three centuries of the City of Light. In 2012 she started a bespoke tour company, leading visitors in museums and in the footsteps of artists and poets such as Charles Baudelaire, who invented the term *flaneur*, or to Montmartre and Le Bateau Lavoir, the birthplace of Cubism. She has made appearances on the History Channel and National Geographic talking about *affaires culturelles* in the city that has contributed so much to the development of art and literature.

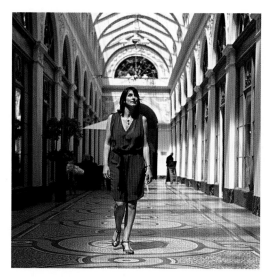